IMAGES
of America

BOULDER CITY
NEVADA

Thank you for supporting Sierra Pacific Resources in their daily goal to deliver safe and reliable power to the people of Nevada

Mimi Garat Rodden

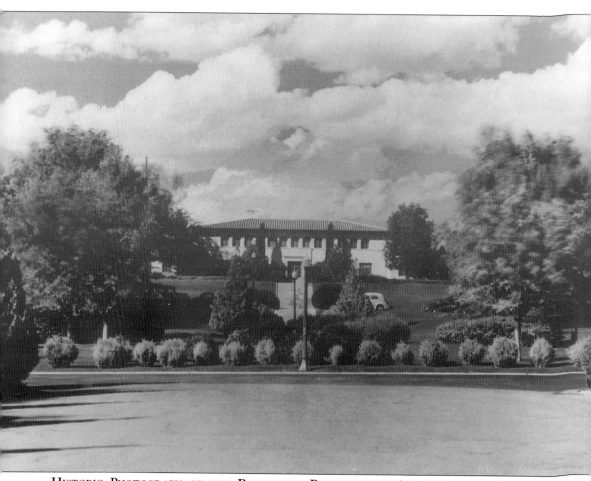

HISTORIC PHOTOGRAPH OF THE BUREAU OF RECLAMATION ADMINISTRATION OFFICES.
(Courtesy of Bureau of Reclamation.)

IMAGES
of America

BOULDER CITY
NEVADA

Mimi Garat Rodden

ARCADIA

Published by Arcadia Publishing
Charleston SC, Chicago IL, Portsmouth NH, San Francisco CA

Printed in Great Britain

Library of Congress Catalog Card Number: 00-106605

For all general information contact Arcadia Publishing at:
Telephone 843-853-2070
Fax 843-853-0044
E-Mail sales@arcadiapublishing.com

For customer service and orders:
Toll-Free 1-888-313-2665

Visit us on the Internet at www.arcadiapublishing.com

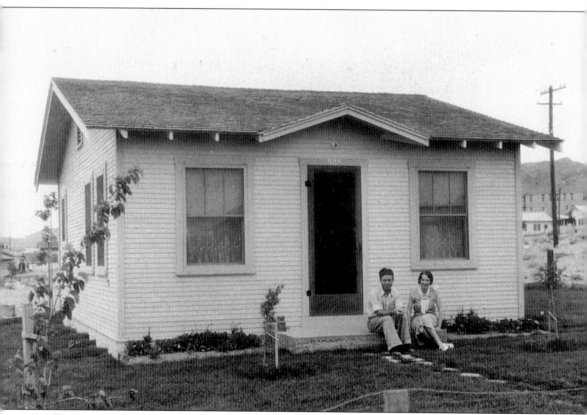

UNIDENTIFIED COUPLE SITTING IN FRONT OF AN ORIGINAL FAMILY HOME. (Courtesy of Boulder Dam Museum.)

DEDICATION

This book is dedicated to all the pioneers who came to Nevada to make this a better

state, and to the pioneers who helped settle the West.

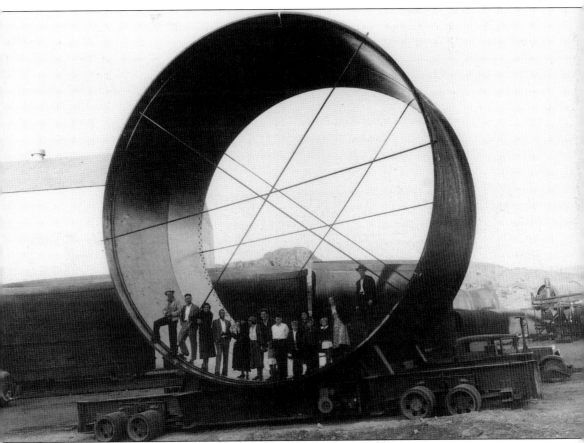

AN EARLY BOULDER CITY FAMILY IN A 30-FOOT PENSTOCK PIPE SECTION LOADED ON A 32-WHEEL TRAILER FOR TRANSFER FROM THE BABCOCK & WILCOX ROLLING MILL TO HOOVER DAM DIVERSION TUNNELS. They are, from left to right: Everett Godbey, Bun Godbey, Lee Godbey, Dal Baileny, Lina Fahrion holding granddaughter Alice Mae, Erma Godbey, Tom Godbey, Ila Godbey, Monroe Sullivan, Tommy Godbey, Alice Sullivan, Jimmy Godbey, Laura Godbey, Sammette Sullivan, and Joe Sullivan, on December 25, 1931. (Courtesy of Godbey Family.)

ACKNOWLEDGMENTS

The author would like to thank Dennis McBride, Marti Barth, and Joan Kerschner for their contributions towards this book.

Photo Credits

Boulder City Museum and Historical Association, American Legion Post 31, Bureau of Reclamation Department of the Interior, The Godbey Family, Grace Community Church, Rose Ann Miele Rabiola, MRPC, Mimi Rodden, Preservation Consultant.

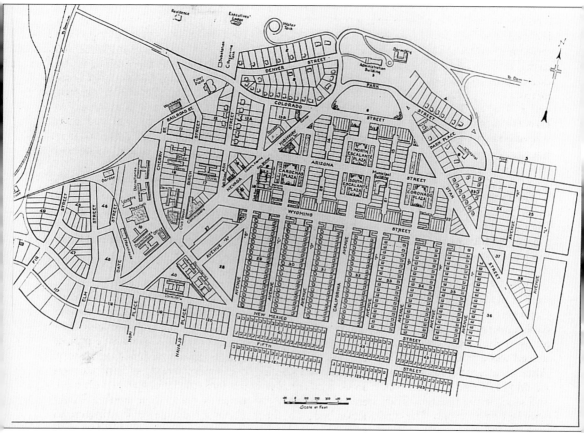

PLAN OF BOULDER CITY SHOWING THE LOCATION OF BUILDINGS ALREADY CONSTRUCTED OR UNDER CONSTRUCTION. Most of the structures at the left and in the lower section of the city plan were built by one of the Six Companies for their employees. (Courtesy of Boulder Dam Museum.)

INTRODUCTION

In the beginning, it was a dream—a dream to harness the mighty river for much needed power, and to control the terrible flooding of the lower Colorado. Seven states would have to agree on goals as well as the distribution of water, the "gold" of the west. Beautiful western vistas, open spaces, and opportunities beckoned with the promise of new land and new beginnings. All of this amidst the time when the United States was beginning to experience the worst depression in history.

The Boulder Canyon Project Act, as authorized by Congress in 1928, was intended for the construction of Hoover Dam. This was the most significant American public works project of the twentieth century. The first and largest of our nation's monumental multipurpose reclamation efforts was to tame the awesome Colorado River, a Spanish word meaning "red river." Hoover Dam and the support construction crew were to transform the economy of the Southwest by supplying domestic and industrial power to southern California's ever-growing metropolitan areas, and to control flooding in the vast agricultural valleys. This gigantic undertaking would require thousands of construction workers. The project was estimated to take between five and seven years to complete. Previous reclamation projects had been supported by temporary construction camps; however, a support facility in the middle of a very hot and barren land—a cactus-covered desert with sand-driven winds—required some real planning.

The Bureau of Reclamation drafted the town of Boulder City, a model city, to meet the needs of the four to five thousand workers. This plan became a significant part of the entire Boulder Dam project. The first fully-planned city was to chart the course for the infant Community Planning Movement. Today, the design of Boulder City is recognized as a force of great influence in modern city planning.

Of equal importance was the tremendous need for employment. The entire United States, as well as most of the world, was out of work—no jobs and no money. By 1933, the Civilian Conservation Corps was formed, and Congress was pressed to find work for them. One can easily understand the job potential—a new migration to Boulder City was on. People came from all over; they came by the thousands, by car, wagon, horse, and train. This massive project indeed was a prayer answered during one of the most hopeless periods in American history. After a few months in tent camps, shanties, and sleeping in wagons or cars, these desperate men would finally find work. Working under unimaginable conditions, the job would provide food, and soon, living quarters. They were even able to send money home to their families. Times were bad for everyone. The construction budget of the project was too large for Washington, so a consortium of construction companies—the Utah Construction Company, the Henry J. Kaiser Company, the W.S. Bechtel Company, MacDonald and Kahn Company, the Morrison-Knudson Company, and J.F. Shea and Company—formed a new group, the Six Companies, to simply do the work. Government bonds backed the project.

The Bureau of Reclamation hired Saco Reink DeBoer, newly recognized master planner, in 1930. Born and educated in the Netherlands, he had also studied landscape architecture in Germany and England. DeBoer was considered one of the master city planners of the 20th century. He applied a completely new concept to town planning when he charted Boulder City. At the time the Boulder City plan was commissioned, significant, dramatic, and lasting changes that shaped contemporary urban development witnessed an evolution. Concern for the beautification of cities, parks, and open spaces, recognizing the need for regional planning, and the hope of improving human and social conditions were true goals. The Boulder City Plan, drafted between July and December of 1930, was the first test of a fully planned and developed new town in the United States.

DeBoer's design for Boulder City had, as the key element, a civic center of government structures resting on the crest of a hill. The focal point leading to the "center" is a large park, which reinforces the formal setting of the civic center. Three primary streets radiate in a fan-like configuration from the "center." DeBoer chose the names for the streets from the seven western states directly impacted by the Colorado River reclamation project—Wyoming, Colorado, New Mexico, Utah, Arizona, California, and Nevada.

Boulder City was a "reservation" of the federal government. It was the only reservation of its type—neither Native American nor military. As such, it was not only planned as a reservation, it was organized as a tightly knit community. At one time, a military reservation was contained within the boundary of Boulder City, thus creating a reservation within a reservation. Camp Williston was occupied from 1940 to 1944, and housed approximately eight hundred men. This was part of our nation's World War II preparedness as well as security support for Hoover Dam.

The success of Boulder City as a reservation may be attributed to some unique conditions. First, and perhaps most important, was the government's commitment to the long-term financing and administration of the city. The Bureau of Reclamation acquired complete control of all project lands by designating them a federal reservation, thereby assuring that their objectives would be met. By approving all construction projects, the Bureau assured proper development of the city plan. They also controlled the types and amounts of commercial development through a permit-lease system. They did encourage the development of schools, and social and religious groups. The Bureau was absolute in its enforcement of rules governing the conduct of the citizens of the reservation. The city manager, Sims Ely, was hired to carry out the government's policy of strict control of all town site activities. He issued all permits for private buildings, collected all city revenues, and supervised all public works. Mr. Ely also followed the health and general welfare of all residents. He was the law; anyone caught violating the rules, specifically gambling or alcoholic consumption, dealt directly with Sims Ely.

After the innovative planning of Boulder City, the federal stewards were responsible for proper maintenance of the reservation. Recognizing the importance of the project, and realizing the eyes of the world were watching, they wisely hired Wilbur Weed, a well-known Oregon landscape architect. Mr. Weed was hired to complete the city's design as well as to supervise the landscaping of all streets, parks, and public buildings. In late 1931, Congress made a large special appropriation for completing all the remaining landscaping in Boulder City. After weeks of study, the proper plants were chosen, and the landscaping began. Early in 1932, the government portion of Boulder City was transformed from a dusty, wind-driven desert to green lawns and gardens, making Boulder City an oasis in the desert. The Six Companies hired Justin Barber, their own landscape architect, to landscape their administrative buildings. Mr. Barber generally performed desert landscaping.

As a federal reservation, the Bureau issued the orders. Construction of nine brick residences

was started on Utah, Nevada, and Denver Streets. The homes were intended for ranking Bureau of Reclamation staff members. Each of the houses measured 28 feet in depth and 44 feet in length, and contained two bedrooms, a bathroom, a kitchen, a living room, and a dining room. Some of the first, more important houses even had basements. Exterior design was of the Spanish Colonial period with Revival overtones. The homes were constructed of rowlock brick and roofed with double-pitched Spanish clay tile. The houses were extremely well-constructed and contained exceptional woodwork and interior details.

City construction began with the large water tank in the spring of 1931. Construction was heavy and lasted until late 1933. Access to the dam site from this new city was convenient and easily provided by double-decker buses. The government had decided against locating the reservation in the small railroad town of Las Vegas, which was quite a distance away and had a reputation the Bureau did not wish to adopt. There was to be no drinking or gambling on the reservation. Under the stern and watchful eye of Sims Ely, the first city manager, control was absolute. Population at the height of construction was estimated at eight thousand. The primary emphasis of the town was to economically and comfortably house the men who would build the dam. The city had over 1,500 permanent and temporary structures, as well as all basic infrastructure needed for support systems—sewer, water, electricity, and roads. Organizations, churches, schools, fraternal groups, and private businesses were encouraged. There were tremendous periods of growth, and the sense of community was very strong. This town had a sense of purpose, a strong camaraderie—qualities much appreciated during the Depression.

Upon completion of the project, the community's needs changed, population was reduced, and community functions changed as well. Soon other government-related agencies began operations in Boulder City. Both residential and administrative facilities would be needed by the power operators, charged with the distribution of electricity from the Boulder Dam Project.

The Bureau of Reclamation residential area consists of the earliest permanent housing. The Bureau standardized five floor plans. This was done without creating the monotony of similar houses all in a row. Different styles were used in order to vary the architectural character of the streetscape. There is, however, a rhythm to the houses—they all had green grass in front and no driveways.

High on the hill above Denver Street, one can see the first construction, the water tank. On the next hilltop you will notice two large mission-style houses. One is the Executive Lodge for Six Companies, Inc., the general contractor for the dam. This ten-room structure was used to lodge visiting dignitaries. President Herbert Hoover and many other heads of state were interested in this modern marvel of the world and visited the project site. Frank Crowe, superintendent of the Six Companies, occupied the second house. During his career, between 1905–1946, he supervised construction of 19 important dams. He so inspired his men and their work that they were able to complete the Boulder Dam Project 22 months ahead of schedule and under budget. Mr. Crowe received a huge bonus for completing the work in such a manner.

At the corner of Nevada Highway and Ash Street you will notice a large angular brick building, the Los Angeles Water and Power building [LAWP]. Originally called the Bureau of Power and Light, this company is one of the two agencies contracted to operate the power generators at Hoover Dam and to distribute electricity to southern California. The power building was built in 1939–1940. Administrative and public offices were housed in front or along Nevada Highway and along the Ash Street side. The balance of the deceptively large building handled all repair work. The structure also houses a large utility courtyard and several working bays. Immediately adjacent to the Los Angeles Water and Power building are five duplexes. These charming units were completed in February 1941, and constructed to house the

first employees of the LAWP. At that time each unit contained its own covered garage. Those garages are attached to the LAWP structure. Each unit has parking in the back alley, and a nice lawn with a pergola used to fill the center courtyard. The chronology of the LAWP follows:

- Hoover Dam power contracts are negotiated, operation awarded to Southern California Edison Company and to the Bureau of Power and Light of the City of Los Angeles (a.k.a. LAWP).

- Power is first generated at Hoover Dam in October 1936.

- Construction contract for LAWP building awarded in 1939 to Paul Webb, a private contractor who built Boulder Dam Hotel (1933–35), Uptown Hardware Store and Apartments (1939), Rose de Lima Hospital (1942), Nevada Drug Store (1940), and National Park Service headquarters (1952).

- Bureau of Power and Light Building was occupied in May 1940.

- Congressional subcommittee hearing on Boulder City incorporation is held in the auditorium, Nevada Representative Cliff Young officiated.

- Congressional subcommittee again held hearing on incorporation, Nevada Senator Alan Bible officiated.

- Los Angeles Department of Water and Power began divesting its Boulder City property in anticipation of turning over power operations at Hoover Dam to the Bureau of Reclamation after 1987.

- Hoover Dam's bond is paid off with interest, and power operations reverted to the Bureau of Reclamation.

- Boulder City was chartered in 1959.

- City of Boulder receives the deed for the Power and Light Building, 1995.

The LAWP neighborhood emerged as one of the most pleasing in the entire Boulder City Historic District. The homes on Birch, Ash, and Cherry Streets were all built between 1936 and 1943 and were used to house the power operators. The 400 block of Ash Street was comprised of Six Companies foremen's homes. Each house had one, two, or three rooms and included screened-in porches. They were sensitively designed, each with near-white stuccoed walls and red tile roofs. The houses were built from three basic floor plans, which alternated along the streetscape. Again there were no driveways in front, just rolling green grass—a pastoral image of quiet and calm.

Two hundred and thirty homes bounded by Avenue B, New Mexico Street, California Street, and Wyoming Street were built for married couples in 1931. This housing tract was supplemented in 1932 with an additional 430 cottages, bringing the total to 660. These small frame houses were meant to be temporary. About a third of the homes were demolished as per the original agreement between the Bureau of Reclamation and the construction company. Those homes left standing were sold upon completion of the construction of the dam. Many were sold or moved by individuals wishing to remain in Boulder City. The sales began in 1935, and the houses on the 400 block of Ash Street were purchased by LAWP in 1936. At that time none of the structures had been modified. After that date most homes underwent some

remodeling. Generally changes were necessary to accommodate larger families as well as to maintain the standard of efficiency desired in today's homes.

Southern California Edison Company, the second power operator at Hoover Dam, constructed the houses on Cherry Street. This group of houses, built in 1939, utilized four floor plans in consecutive, repetitive order along the streetscape. Landscaping has been carefully maintained to provide gently sloping, grassy lawns and mature shade trees. This streetscape is one of the most well-preserved in the historic district, because, together with the subtle diversity of the house models, it gives one the context of the neighborhood.

Boulder City's historic commercial district is small and compact. The Coffee Cup Restaurant, '50s Diner (previously the Green Hut), and Ace Hardware are some of the oldest buildings in Boulder City. Nevada Highway and Avenue B host some of the oldest buildings. The theater, 1932, is also one of the older buildings in the area. It was the largest movie house in Nevada with a seating capacity of 728 people and a real stage for live performances. One very important amenity of the theater was the fact that it operated 24 hours a day and was refrigerated. Many workers went there to seek relief from the blistering heat, and many went to rest or sleep.

The original city plan called for arcades on the commercial blocks surrounding three landscaped parking plazas in the center of town. Special emphasis was placed on creating easy pedestrian access from shop to shop. The architectural style was southwestern, a guideline to ensure visual continuity of these large multi-use buildings and to create a shopping district somewhat like our shopping plazas of today. These large buildings had multiple business tenants and some living quarters.

Accommodations were needed in order to cope with the growing number of visitors arriving to view the progress of this eighth wonder of the world. A private contractor built the Boulder Dam Hotel. It is the most conspicuous deviation from the southwestern appearance suggested by the architectural guidelines. Fine hospitality and a richly appointed building with a bath for every room made this hotel very popular. Structures built in the business district after 1940 mainly reflect the International style. A fine example of this is the National Park Service Headquarters at Nevada Highway and Wyoming Street.

The Bureau of Reclamation Regional Headquarters at Park Street, known as the Administration Building, is one of the most dominant structures in Boulder City. Completed in January 1932, it housed the offices of the chief construction engineer and other Bureau of Reclamation staff during the construction of the dam. Slightly east of this is the government dormitory which housed unmarried engineers. It now serves as additional space for administrative offices. Both buildings are fine examples of southwestern architecture, which is characteristic of the original plans for the city. One of the more important houses, located at Park and Utah Streets, belonged to Sims Ely, City Manager from 1931–1941. Further along Park Street, a two-story red brick structure, built by the Bureau, belonged to J.R. Alexander, Chief Counsel. The original hospital is located across the street. It was built with three additions in just one year by Six Companies. The site is now known as Wellspring and is run by the Sisters of Charity, an Episcopal Order, and serves as a retreat house. Wilbur Weed's home is on the corner of Utah and Arizona Streets. He should receive most of the credit for establishing the lovely parks and the beautiful trees on the residential streets, and all of the older or mature trees in the downtown core area. St. Christopher's Episcopal Church, facing Coronado Plaza, built in 1932, and the Grace Community Church, which held its first service in the new building in 1933, are the only two remaining original churches downtown. The Recreation Department building served as the original high school. Next to that building, the current city hall was the first permanent grade school. Because Boulder City was a reservation, its residents

were tax-exempt. This did create problems in building and operating schools. Across Arizona Street is the original Boulder City Municipal Building. Completed in January 1932, it housed the city manager and his staff, the public library, and the police department.

Looking up the hill, or to the north across Railroad Avenue, the City Water Purification and Filtration Plant is visible. This structure, with its red-tile-roofed tower is an example of the highest style and the government's most outstanding construction effort associated with the development of Boulder City. Beginning in 1931, water was delivered to Boulder City from the Colorado River. It required a 12-inch water main six miles in length and rising two thousand feet in elevation. The condition of the water required a pre-sedimentation plant at the river. The elevation change necessitated four pumping stations and five water tanks. This efficient filtration plant, completed in February 1932, was the culmination of the system and was necessary to purify and soften the water before its distribution.

To a country shaken to its roots by the tumultuous effects of the Great Depression, the Hoover Dam project provided two essentials that were in short supply—work and housing. With the planned community of Boulder City, there was yet another benefit—an oasis in the desert, and a city with character and charm.

A NEVADA HIGHWAY RESIDENCE, APRIL 25, 2000. This home was constructed in 1931 for one of the directors of the Hoover Dam Project. (Courtesy of MRPC.)

SIX COMPANIES CAMP UNDER CONSTRUCTION, C. 1931. (Courtesy of Boulder Dam Museum.)

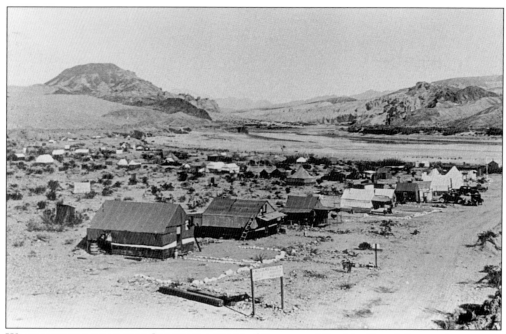

WILLIAMSVILLE NEAR THE COLORADO RIVER. (Courtesy of Boulder Dam Museum.)

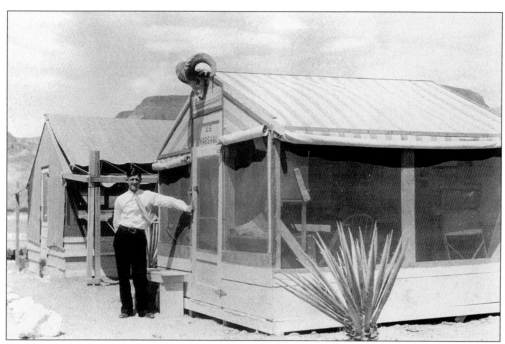

FIRST U.S. MARSHAL'S OFFICE, CLAUDE WILLIAMS, THE FIRST U.S. MARSHAL. He was the law of the town. (Courtesy of Boulder Dam Museum.)

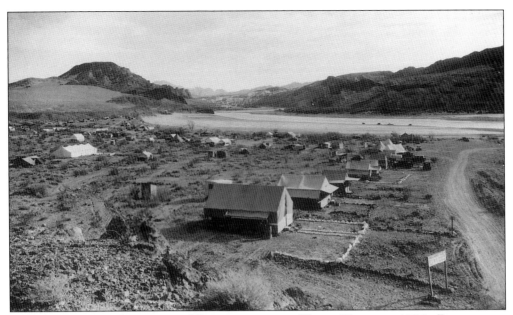

TEMPORARY CAMP KNOWN AS WILLIAMSVILLE OR HELLS HOLE, C. 1932, POPULATION SEVEN HUNDRED. (Courtesy of Boulder Dam Museum.)

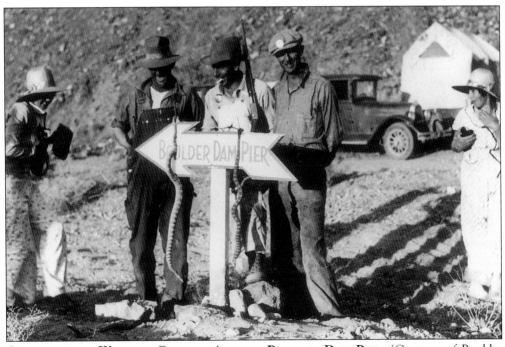

CONSTRUCTION WORKERS GOOFING AROUND BOULDER DAM PIER. (Courtesy of Boulder Dam Museum.)

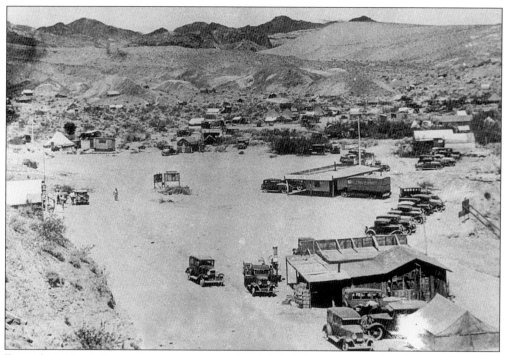

FIRST SETTLEMENT AT WILLIAMSVILLE, C. 1931–32. (Courtesy of Boulder Dam Museum.)

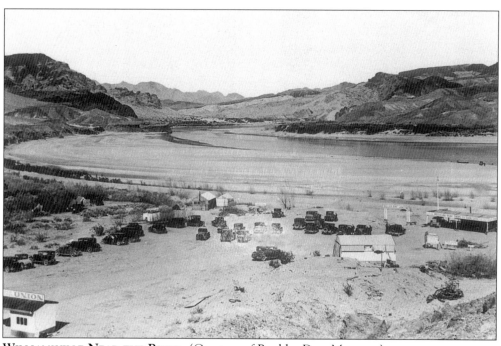

WILLIAMSVILLE NEAR THE RIVER. (Courtesy of Boulder Dam Museum.)

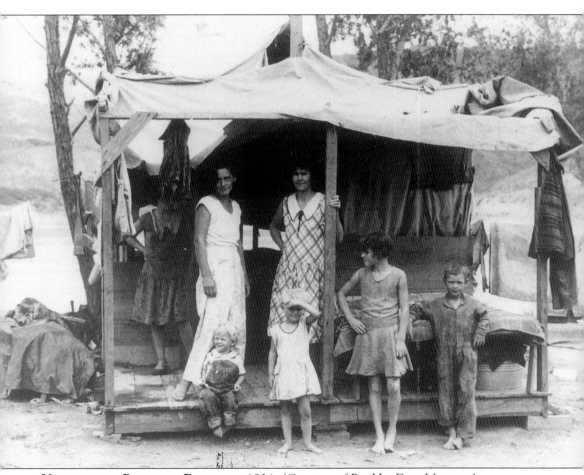

UNIDENTIFIED RAGTOWN FAMILY, c. 1931. (Courtesy of Boulder Dam Museum.)

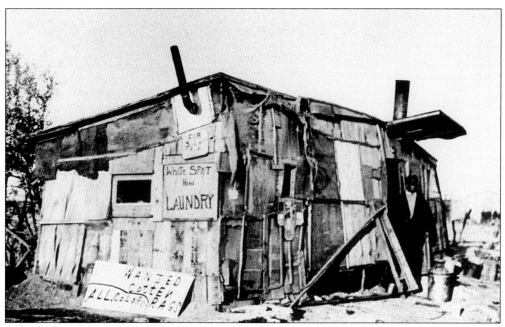

WHITE SPOT HAND LAUNDRY. (Courtesy of Boulder Dam Museum.)

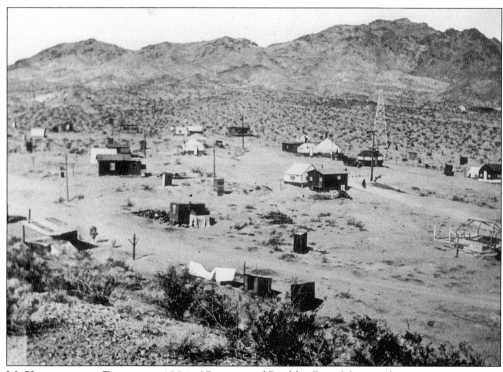

MCKEEVERVILLE, DECEMBER 1931. (Courtesy of Boulder Dam Museum.)

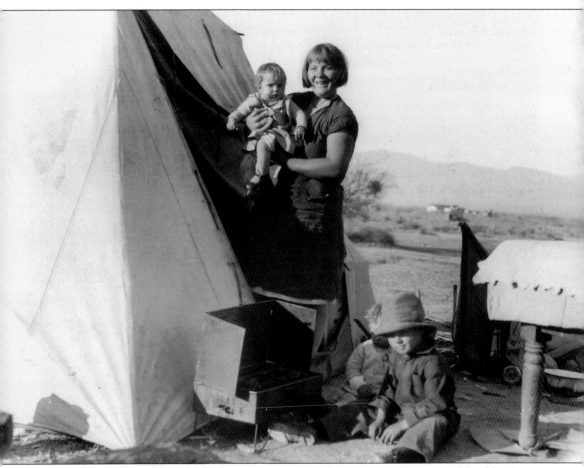

UNIDENTIFIED MOTHER AND CHILDREN, EARLY TENT TOWN. (Courtesy of Boulder Dam Museum.)

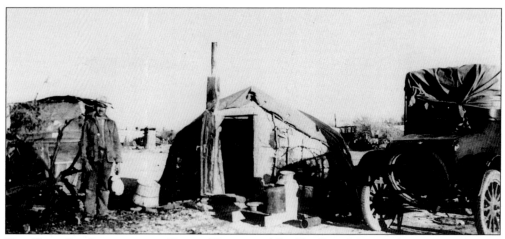

THE FIRST JOB INFORMATION TENT. (Courtesy of Boulder Dam Museum.)

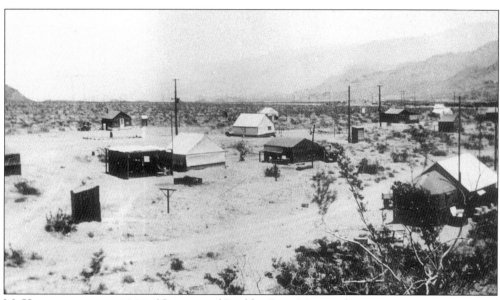

MCKEEVERSVILLE, C. 1931. (Courtesy of Boulder Dam Museum.)

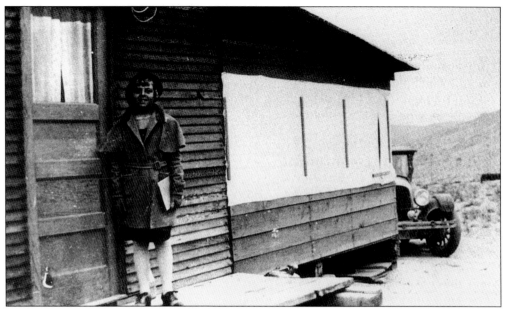

VERLOREE FELTS (BADER) READY FOR SCHOOL. (Courtesy of Boulder Dam Museum.)

LEFT TO RIGHT: HOBART BLAIR, CHARLIE ?, AND JOE ?. (Courtesy of Boulder Dam Museum.)

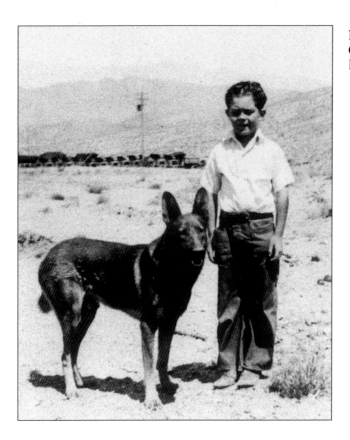

EDGAR BLAIR WITH HIS DOG, COTTON. (Courtesy of Boulder Dam Museum.)

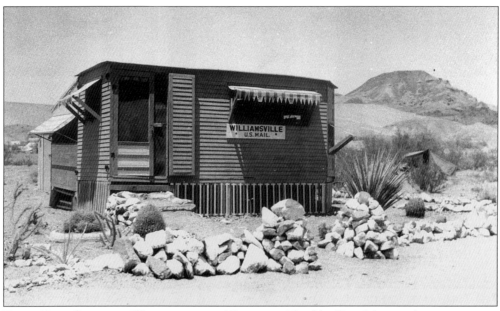

EARLY POST OFFICE AT WILLIAMSVILLE. (Courtesy of Boulder Dam Museum.)

SIGNS AT THE ENTRANCE OF THE BOULDER CANYON PROJECT FEDERAL RESERVATION IN NEVADA, DECEMBER 31, 1931. (Photo by Ben D. Glaha, Courtesy of Bureau Of Reclamation.)

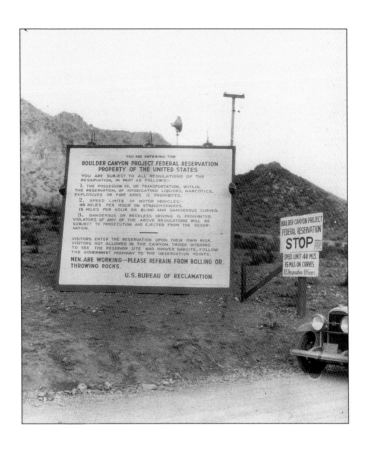

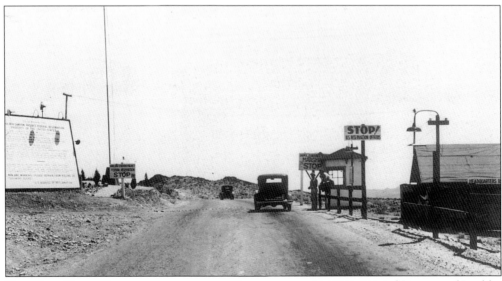

THE TOLL GATE, RANGER STATION, AND RULES OF THE RESERVATION. (Courtesy of Boulder Dam Museum.)

EARLY HOUSES ALONG AVENUES L AND M. (Courtesy of Boulder Dam Museum.)

UNIDENTIFIED MEN REPAIRING A CAR ON A HOT AFTERNOON. (Courtesy of Boulder Dam Museum.)

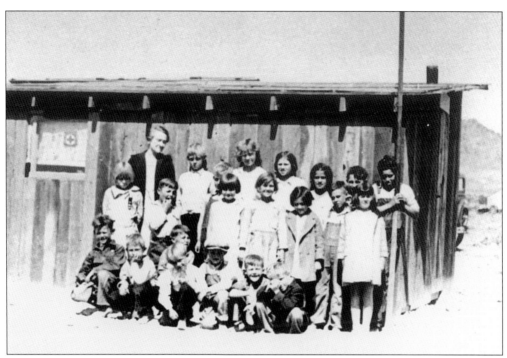

EARLY SCHOOL ON BOULDER CITY TOWN SITE. (Courtesy of Boulder Dam Museum.)

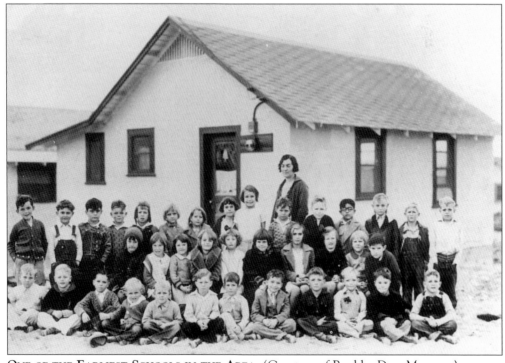

ONE OF THE EARLIEST SCHOOLS IN THE AREA. (Courtesy of Boulder Dam Museum.)

LEFT TO RIGHT: MARJORIE BUCK, LIDA BUCK AND EILEEN BUCK IN FAMILY HOUSING. (Courtesy of Boulder Dam Museum.)

ONE OF THE FIRST CLASSES IN AN EARLY BOULDER CITY SCHOOL. (Courtesy of Boulder Dam Museum.)

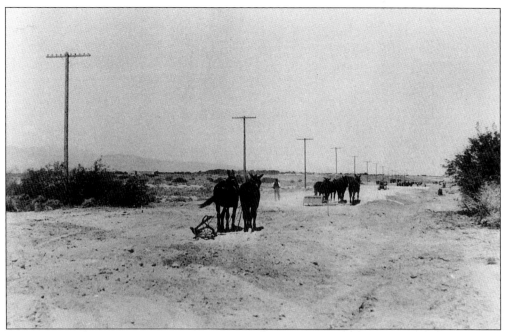

PREPARATION FOR NEW ROAD. (Courtesy of Boulder Dam Museum.)

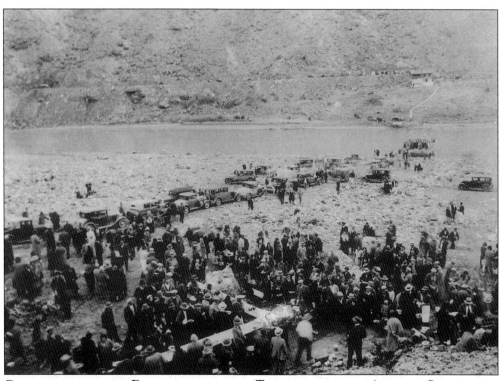

GATHERING FOR THE DEDICATION OF THE TERMINAL ON THE ARIZONA SIDE OF THE COLORADO RIVER—NOTE THE CARS. (Courtesy of Boulder Dam Museum.)

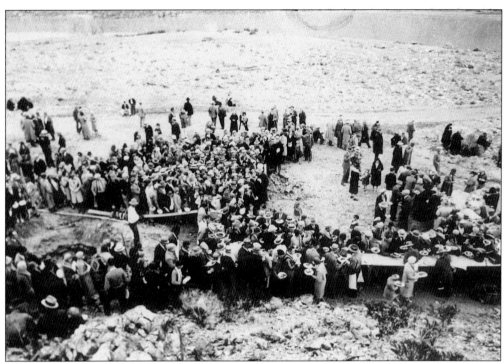

ARIZONA SIDE DEDICATION BARBECUE. (Courtesy of Boulder Dam Museum.)

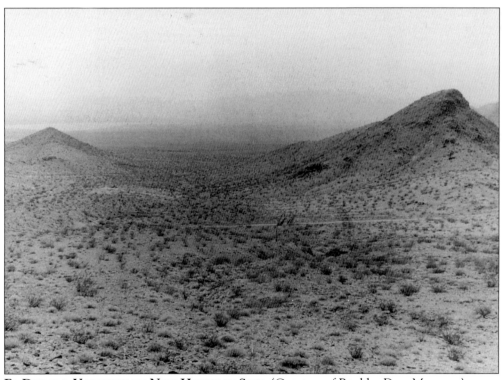

EL DORADO VALLEY FROM NEW HIGHWAY SITE. (Courtesy of Boulder Dam Museum.)

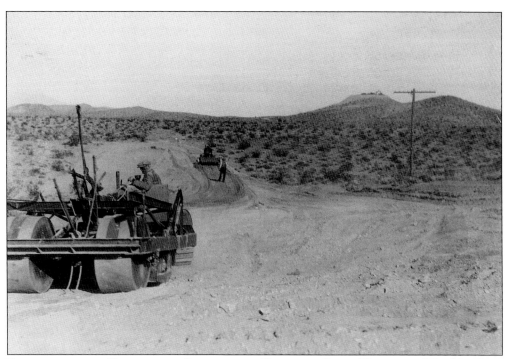

PREPARATION OF ROADS AND STREETS FOR BOULDER CITY. (Courtesy of Boulder Dam Museum.)

ONE OF THE EARLIEST VIEWS OF THE TOWN SITE LOOKING DUE NORTH UP THE HILL TOWARD THE BUREAU OF RECLAMATION ADMINISTRATIVE OFFICES AND DORMITORY FOR UNMARRIED ENGINEERS. (Courtesy of Boulder Dam Museum.)

THE NEW MEXICO CONSTRUCTION COMPANY'S ASPHALT PLANT. (Courtesy of Boulder Dam Museum.)

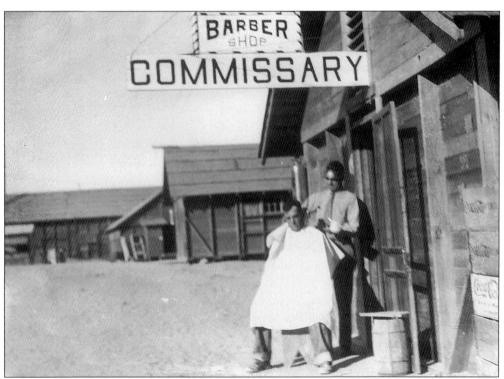

BARBERSHOP AND COMMISSARY. (Courtesy of Boulder Dam Museum.)

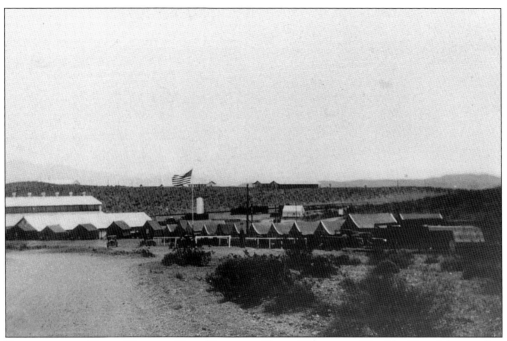

RECLAMATION CAMP NUMBER ONE, BOULDER CITY. (Courtesy of Boulder Dam Museum.)

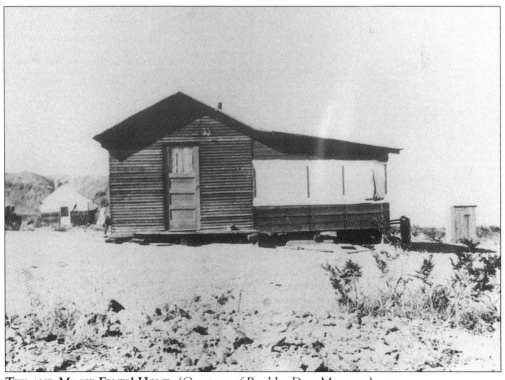

TEX AND MACIE FELTS' HOME. (Courtesy of Boulder Dam Museum.)

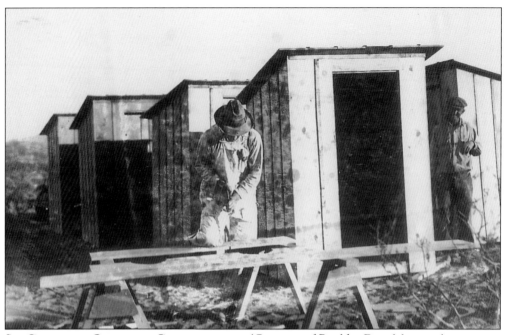

SIX COMPANIES OUTHOUSE CONSTRUCTION. (Courtesy of Boulder Dam Museum.)

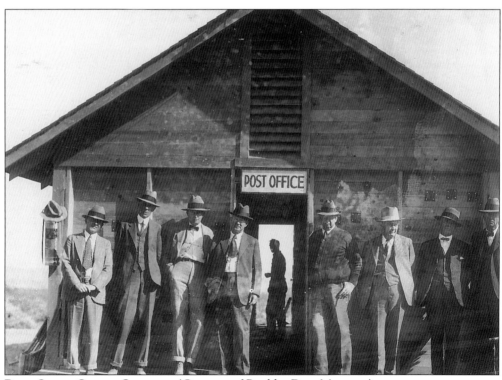

POST OFFICE GRAND OPENING. (Courtesy of Boulder Dam Museum.)

PICKING UP MAIL AT THE POST OFFICE. (Courtesy of Boulder Dam Museum.)

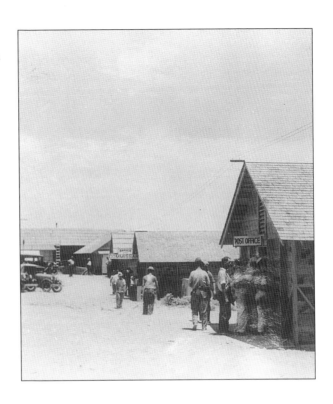

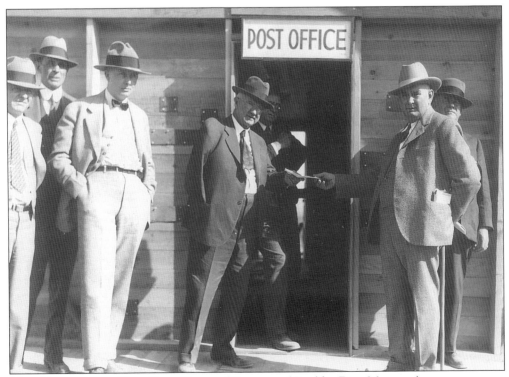

MAIL DELIVERY AT NEW POST OFFICE. (Courtesy of Boulder Dam Museum.)

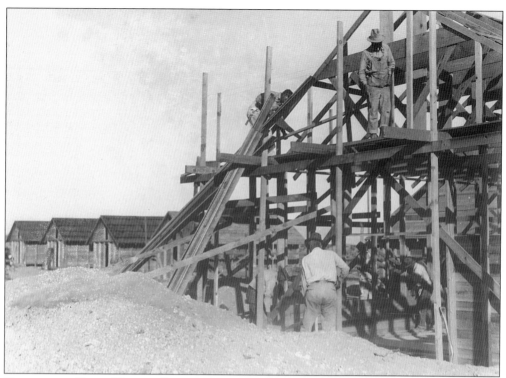

TEMPORARY CAMP UNDER CONSTRUCTION, SIX COMPANIES. (Courtesy of Boulder Dam Museum.)

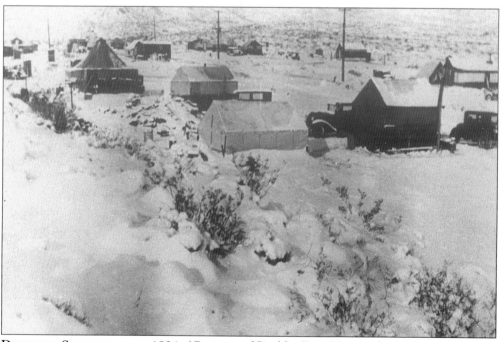

DECEMBER SNOWSTORM, C. 1931. (Courtesy of Boulder Dam Museum.)

EDGAR BLAIR AND UNIDENTIFIED FRIENDS. (Courtesy of Boulder Dam Museum.)

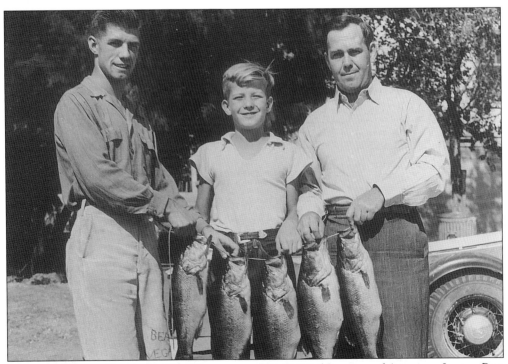

A GREAT DAY OF FISHING—HAP NELLIS AND HIS SONS. (Courtesy of American Legion Post 31.)

ANOTHER CONSTRUCTION PROJECT. (Courtesy of Boulder Dam Museum.)

U.S. BUREAU OF RECLAMATION CONSTRUCTION CREW OUTSIDE THE WATER TREATMENT BUILDING, C. 1931–32. (Courtesy of Boulder Dam Museum.)

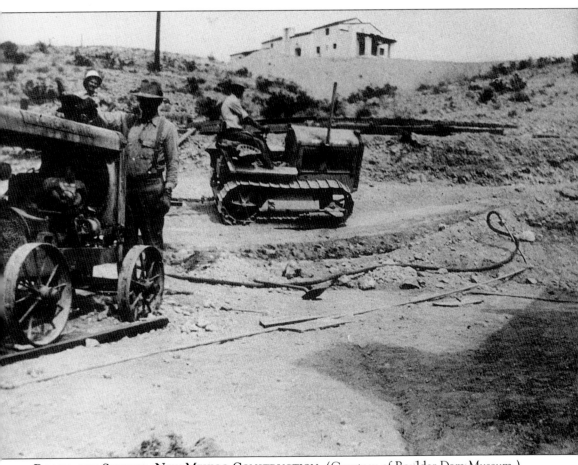

ROADS AND STREETS, NEW MEXICO CONSTRUCTION. (Courtesy of Boulder Dam Museum.)

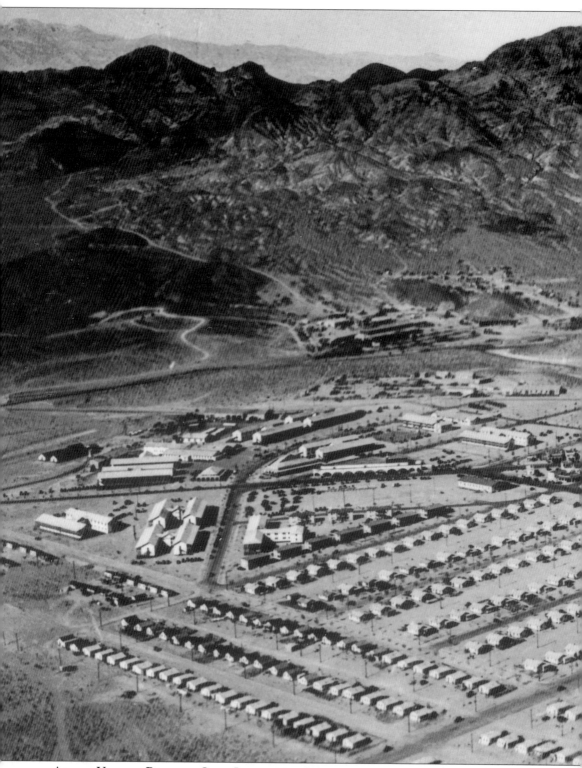

AERIAL VIEW OF BOULDER CITY, LATE 1934. (Courtesy of Boulder Dam Museum.)

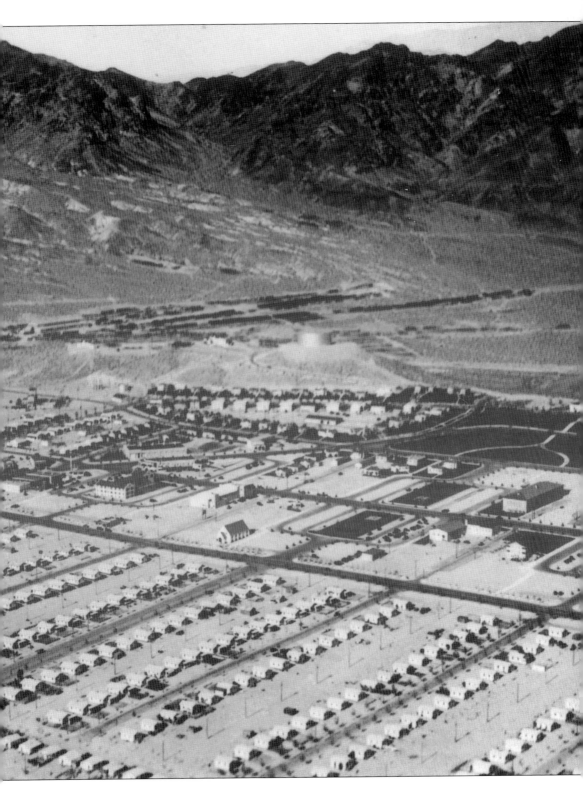

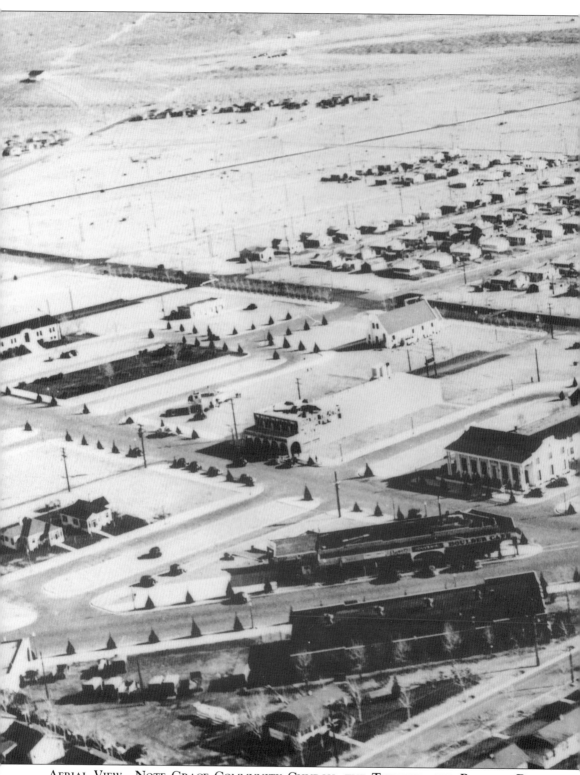

Aerial View—Note Grace Community Church, the Theater, and Boulder Dam

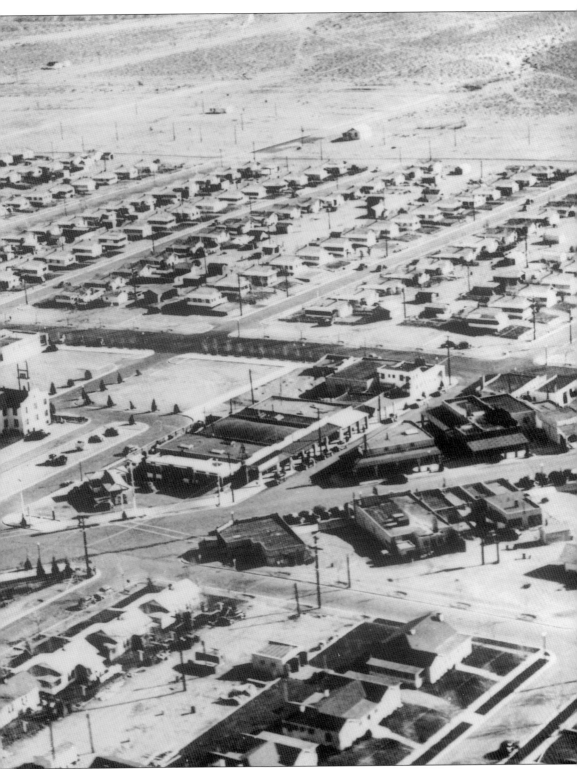

HOTEL IN THE CENTER. (Courtesy of Boulder Dam Museum.)

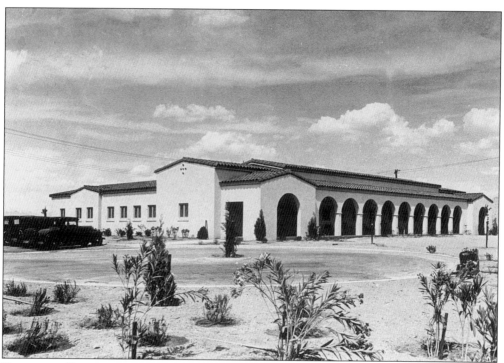

BUREAU OF RECLAMATION ENGINEERS' DORMITORY AND ANNEX. (Courtesy of Boulder Dam Museum.)

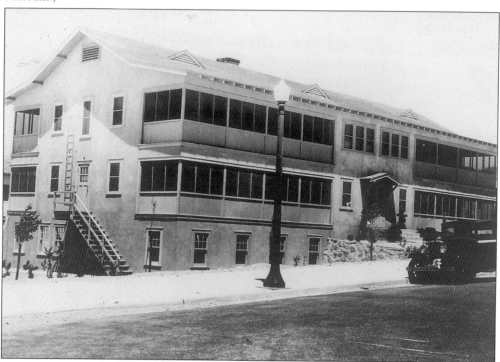

BUREAU OF RECLAMATION DORMITORY NUMBER TWO FOR UNMARRIED MEN. (Courtesy of Boulder Dam Museum.)

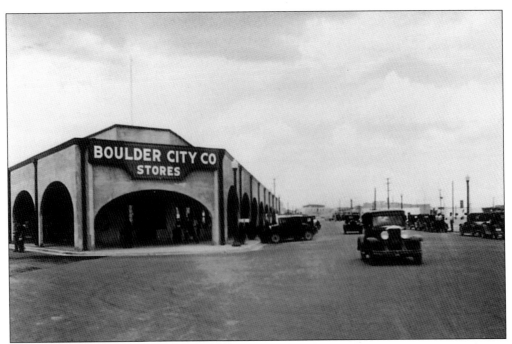

BOULDER CITY COMPANY STORE. (Courtesy of Boulder Dam Museum.)

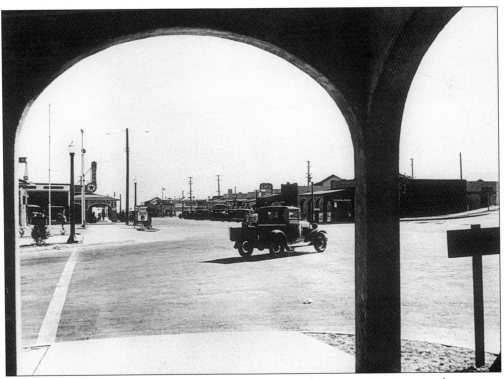

NEVADA HIGHWAY AND ARIZONA STREET LOOKING SOUTH THROUGH THE ARCHES OF THE TERMINAL BUILDING, WHICH WAS DEMOLISHED IN 1941. (Courtesy of Boulder Dam Museum.)

43

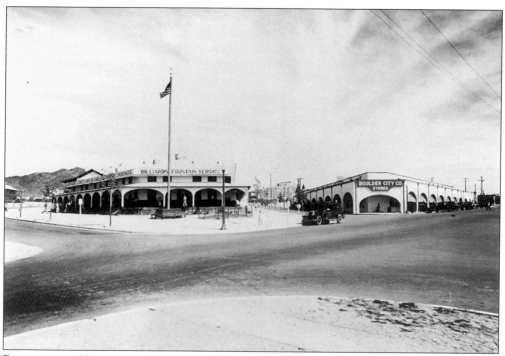

RECREATION HALL AND BOULDER CITY COMPANY STORE. (Courtesy of Boulder Dam Museum.)

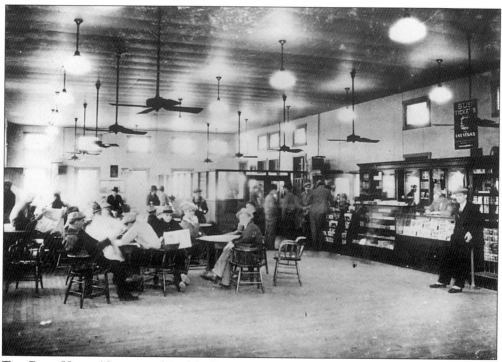

THE POOL HALL. (Courtesy of Boulder Dam Museum.)

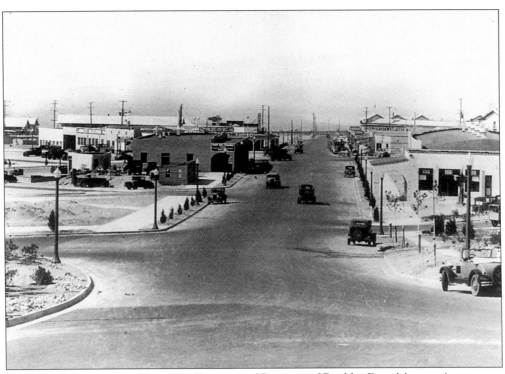

A STREET VIEW OF THE BUSINESS DISTRICT. (Courtesy of Boulder Dam Museum.)

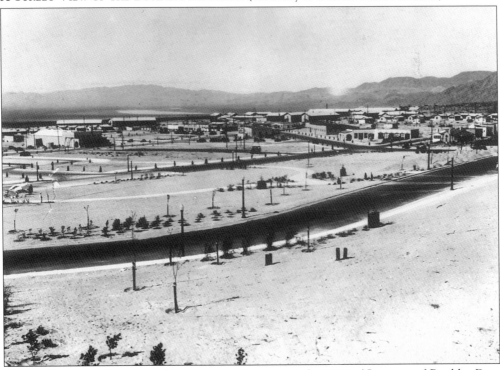

NEWLY PLANTED TREES ON DENVER AND COLORADO STREETS. (Courtesy of Boulder Dam Museum.)

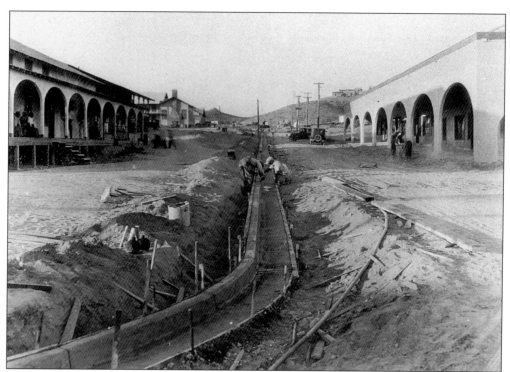

NEW MEXICO CONSTRUCTION COMPANY, INSTALLATION OF CURBS. (Courtesy of Boulder Dam Museum.)

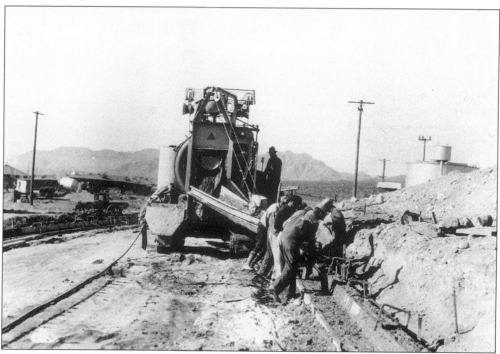

CEMENT TRUCK LAYING CURBING, ROAD CONSTRUCTION CREW. (Courtesy of Boulder Dam Museum.)

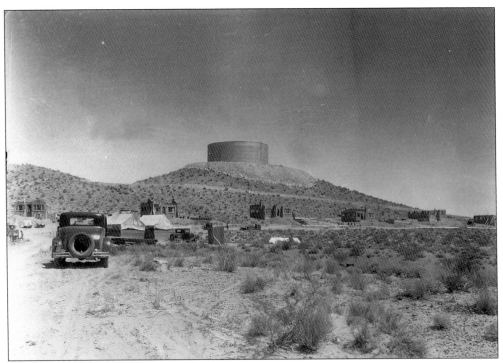

GOVERNMENT HOUSES UNDER CONSTRUCTION, SOUTH OF WATER TANK HILL ON JUNE 2, 1931. (Photo by Ben D. Glaha, Courtesy of Bureau Of Reclamation.)

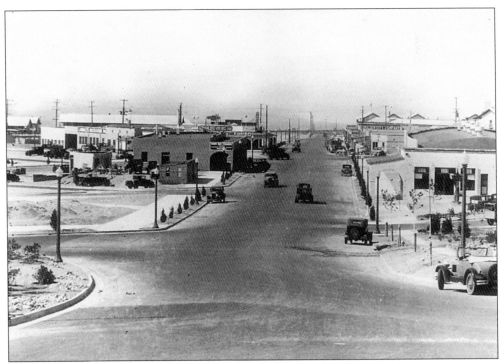

JUNE 3, 1931. (Photo by O.G. Patch, Courtesy of Bureau of Reclamation.)

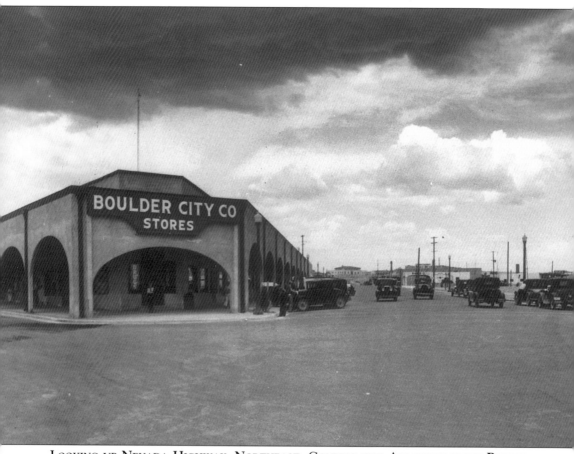

LOOKING UP NEVADA HIGHWAY, NORTHEAST, GOVERNMENT ADMINISTRATION BUILDING ON THE HILL IN THE DISTANCE. The Boulder City Company Store and the business district are visible in the foreground on May 13, 1932. (Photo by W.A. Davis, Courtesy of Bureau Of Reclamation.)

LEFT TO RIGHT: ERMA GODBEY AND HUSBAND, TOM GODBEY, AND NEIGHBORS MRS. ELDER AND MRS. PICKETT. (Photo taken by Mrs. Gillespie, Courtesy of the Godbey family.)

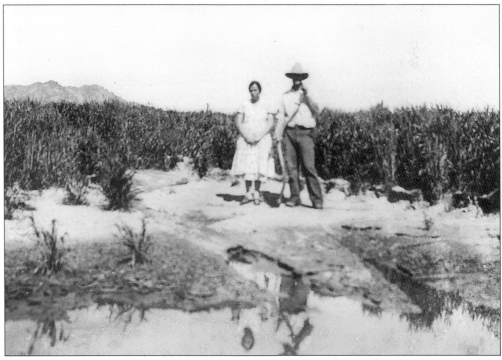

THE GODBEY FAMILY LAKE. It was just a small pool where the Godbey family dammed the irrigation ditch, but it proves they had water. (Courtesy of the Godbey family.)

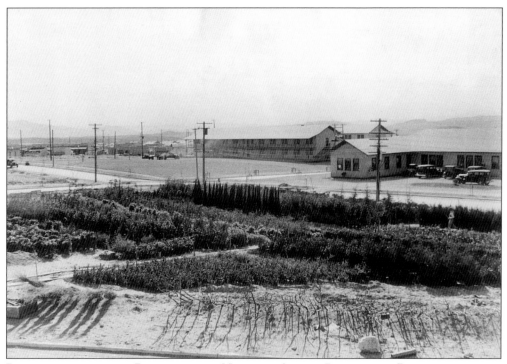

DORMITORIES IN THE BACKGROUND, NURSERY STOCK READY FOR PLANTING IN THE FOREGROUND. (Courtesy of Boulder Dam Museum.)

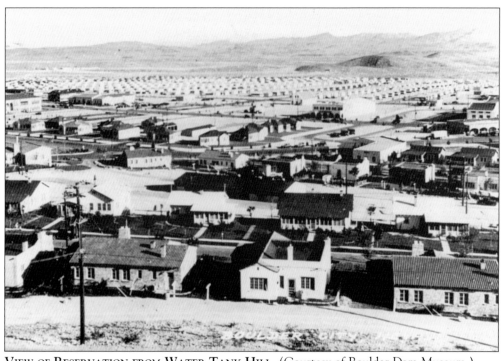

VIEW OF RESERVATION FROM WATER TANK HILL. (Courtesy of Boulder Dam Museum.)

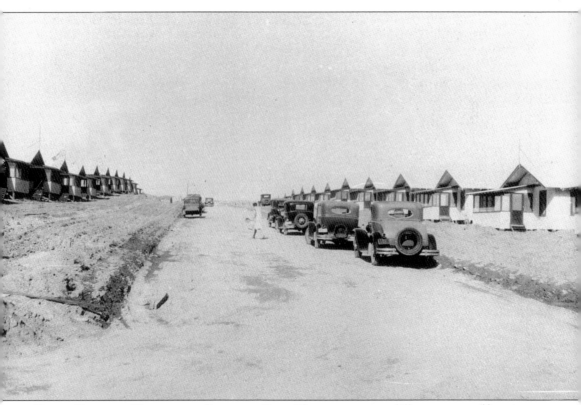

EARLY COMPANY HOUSING IN BOULDER CITY. There were many different tracts of housing. Each tract was developed in response to a new phase of construction or the operation and distribution of the power created by the dam. (Courtesy of Boulder Dam Museum.)

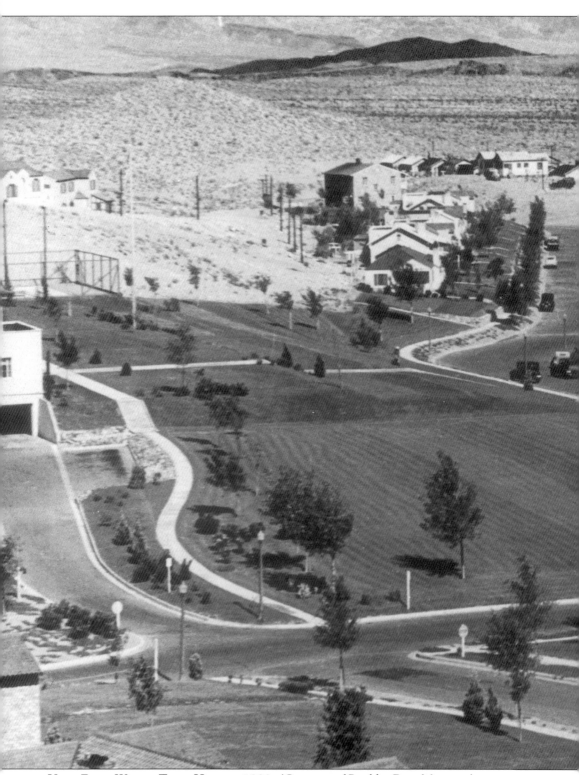

VIEW FROM WATER TANK HILL, C. 1933. (Courtesy of Boulder Dam Museum.)

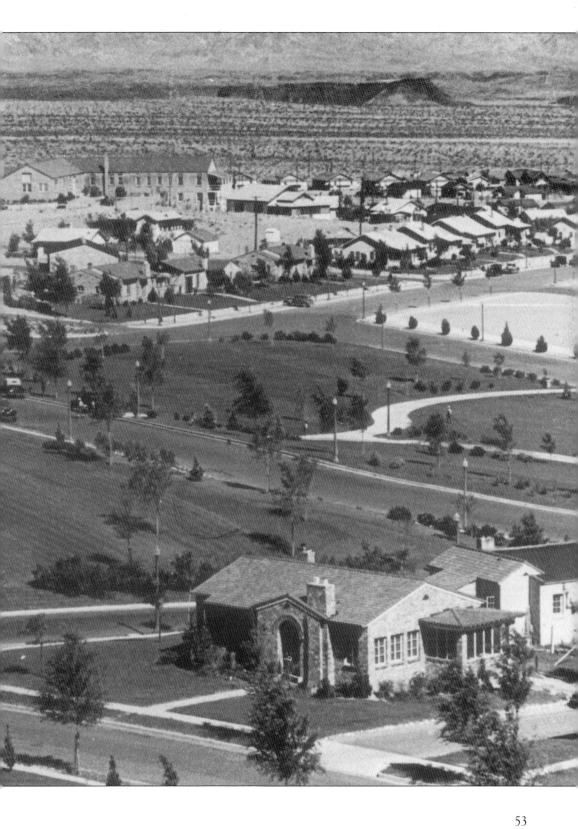

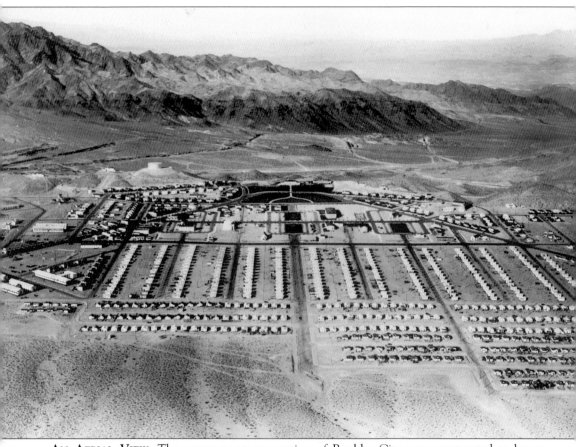

An Aerial View. The government reservation of Boulder City was constructed to house workers of the then-massive Black Canyon Project. The town is a well-planned oasis, fanned out to overlook the El Dorado Valley, a desert, and the mountains beyond, *c.* 1934. (Courtesy of Boulder Dam Museum.)

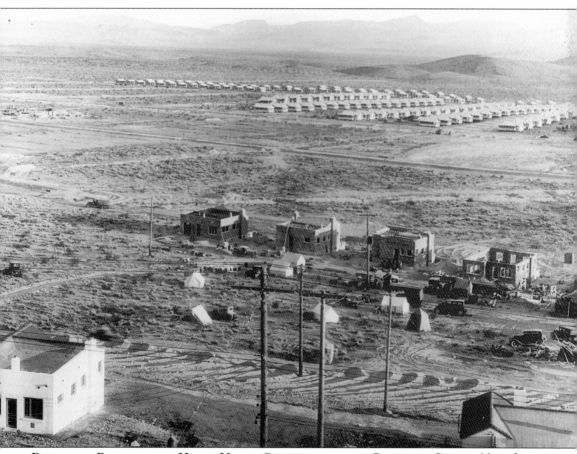

BUREAU OF RECLAMATION HOMES UNDER CONSTRUCTION ON COLORADO STREET. Note the tents in the center of the picture and family housing in the background. Bureau of Reclamation construction supervision is in the foreground. (Courtesy of Boulder Dam Museum.)

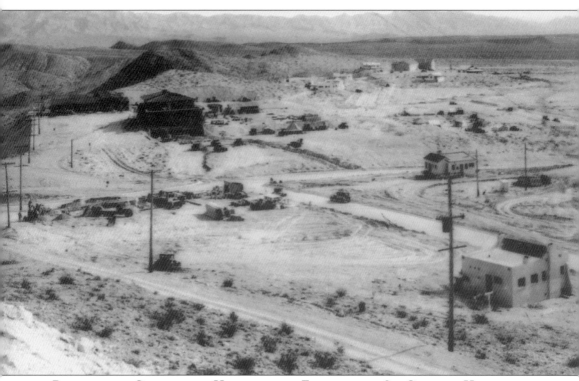

Panorama of Government Houses in the Foreground, Six Company Houses in the Center Background. The long buildings were bunkhouses. Visible in the right hand corner are Warehouse Depot and New Mexico Camp. An unprecedented gale of wind swept in from

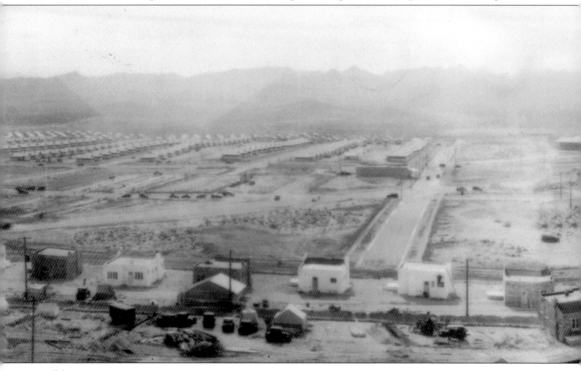

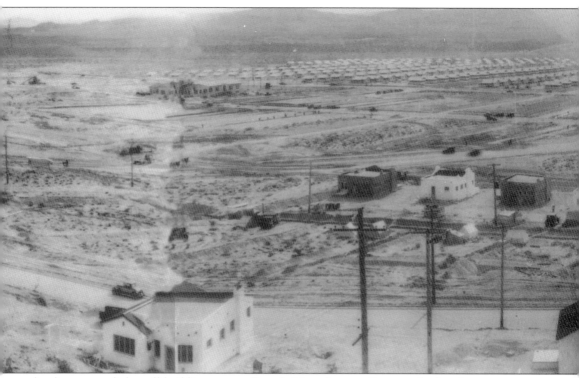

the desert, toppled small buildings, tore off roofs, blew down walls, screeched and tore at new construction, sent workmen's tents flying into the air, and caused other damage in Boulder City in 1931. (Courtesy of the Godbey family.)

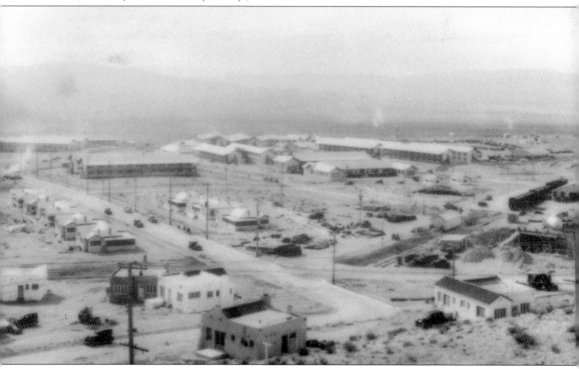

UNIDENTIFIED PAPER BOY. (Courtesy of Boulder Dam Museum.)

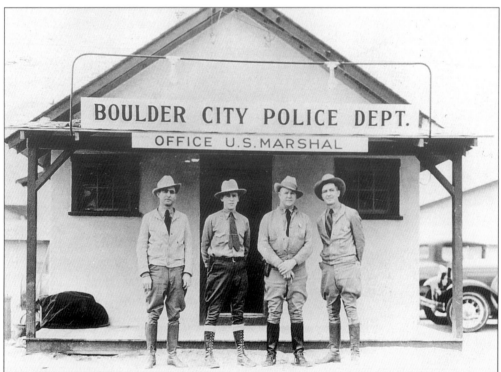

BOULDER CITY POLICE DEPARTMENT AND OFFICE OF THE U.S. MARSHAL. (Courtesy of Boulder Dam Museum.)

UNIDENTIFIED GIRLS IN FAMILY HOUSING TRACT. (Courtesy of Boulder Dam Museum.)

UNIDENTIFIED LITTLE BOY WITH HIS WAGON IN FAMILY HOUSING. (Courtesy of Boulder Dam Museum.)

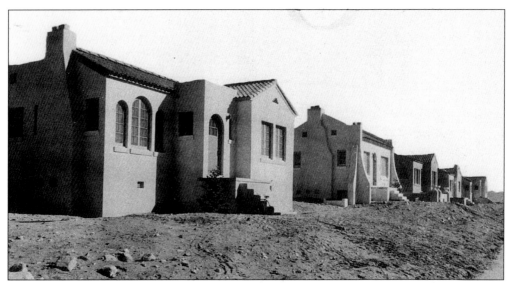

RESIDENCES OF TOP GOVERNMENT EMPLOYEES. (Courtesy of Boulder Dam Museum.)

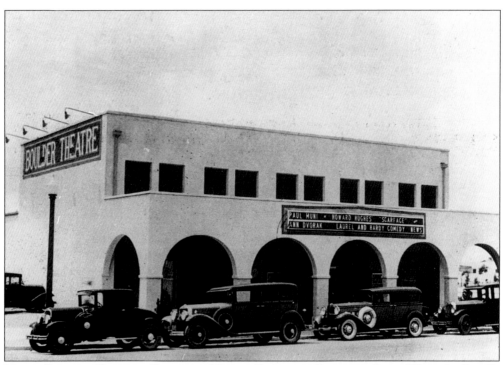

MOVIE PICTURE THEATRE OPERATED UNDER PERMIT IN BOULDER CITY. (Photo by Ben D. Glaha, Courtesy of Bureau of Reclamation.)

It's Yours
THE NEW
Boulder
Theatre

Being equipped with the latest in sound reproducing mechanism, a Carrier refrigerating system, acustone treated walls, magmascope screen and comfortable seats, the new Boulder Theatre, we sincerely feel and trust, will please you.

Every effort will be put forth at all times to show only the finest in motion picture entertainment and with the admission prices which will be in effect, we hope you will enjoy visiting us often.

The Management

Adults—Any Seat, Any Time, 40c Children 10c

ONE OF THE EARLIEST NEWSPAPER ADS FROM THE *Boulder City Age*, OFFICIAL NEWSPAPER FOR NEWS OF AMERICA'S NEWEST CITY AND HOOVER DAM PROJECT. (Courtesy of Boulder Dam Museum.)

Take A Good Look At It!
WE ARE PROUD TO HAVE BUILT IT
BOULDER'S NEW THEATRE

OPENS
TODAY

OPENS
TODAY

To HAVE BEEN SELECTED TO BUILD THE NEW THEATRE FOR BOULDER CITY WAS GRATIFYING. BUT NOW THAT THE SPLENDID BUILDING IS COMPLETED. IT IS AN EVEN GREATER PLEASURE TO REALIZE THAT WE HAVE BUILT A MONUMENT WHICH WILL ADD GREATLY TO THE HAPPINESS OF EVERY MAN, WOMAN AND CHILD IN THE RESERVATION . . . WE ARE PLEASED . . . AND WE HOPE YOU ALL DERIVE MUCH JOY FROM THIS FINE THEATRE.

NEVADA CONSTRUCTION COMPANY

IRA GOLDRING

C. C. HINCHBERGER

THE THEATRE OPENING IN BOULDER CITY AD FROM THE *Las Vegas Age* NEWSPAPER, EARLY 1932. (Courtesy of Boulder Dam Museum.)

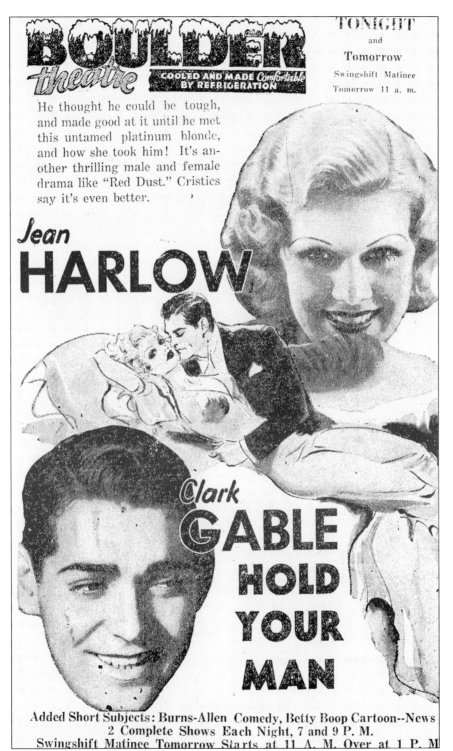

ANOTHER NEWSPAPER AD FOR THE THEATRE, ADVERTISING ITS REFRIGERATION AND SPONSORING A SWING-SHIFT MATINEE. (Courtesy of Boulder Dam Museum.)

63

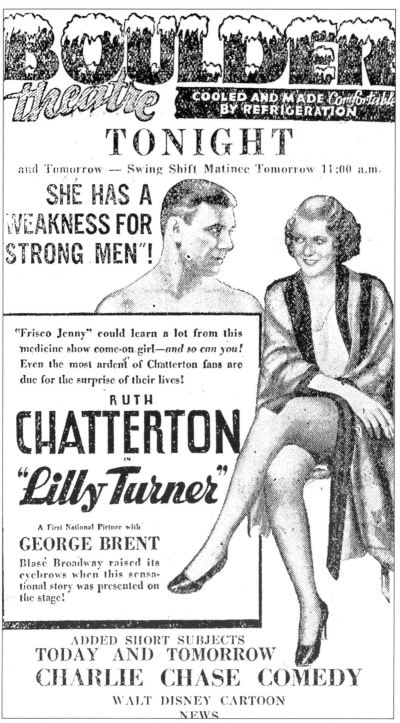

THE BOULDER THEATRE WITH ITS DRIPPING SNOW ADVERTISEMENT. The theatre was offering a movie and a special stage show at 8:30 each night, and at 11 a.m. for the swing shift. The special show was the Hot-Cha Sunkist Beauties program. (Courtesy of Boulder Dam Museum.)

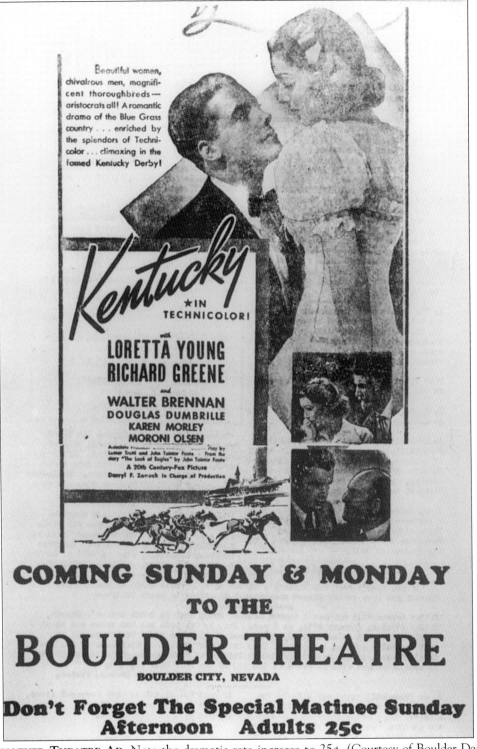

ANOTHER THEATRE AD. Note the dramatic rate increase to 25¢. (Courtesy of Boulder Dam Museum.)

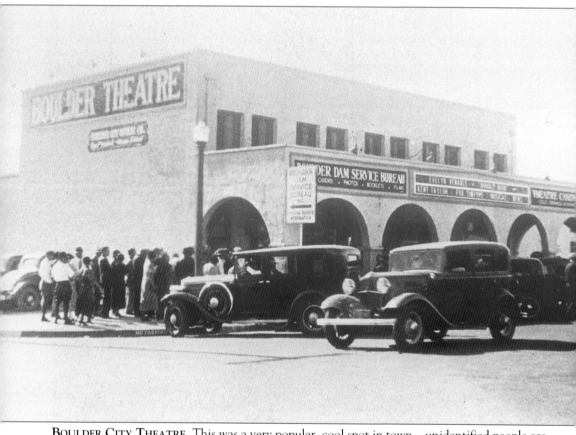

BOULDER CITY THEATRE. This was a very popular, cool spot in town—unidentified people are pictured waiting in line to get into the air-conditioned theatre. (Courtesy of Boulder Dam Museum.)

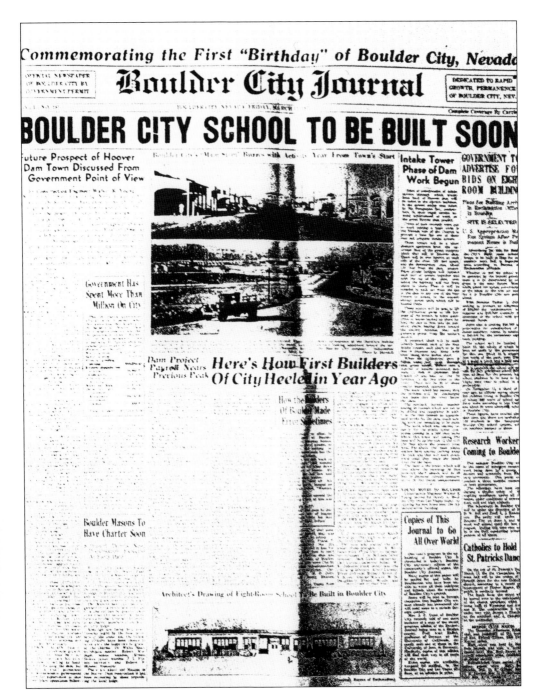

NEWSPAPER COMMEMORATING THE FIRST BIRTHDAY OF BOULDER CITY, MARCH 1932.
(Courtesy of Boulder Dam Museum.)

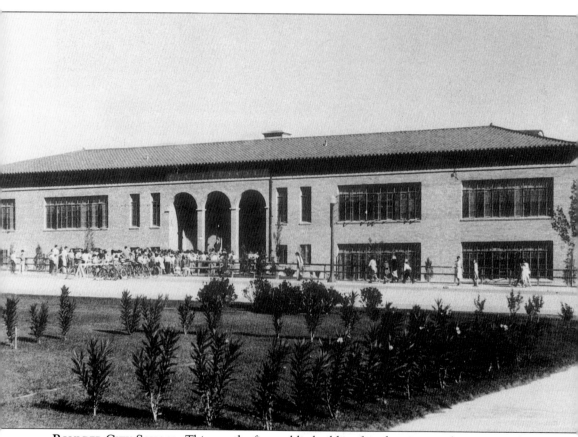

BOULDER CITY SCHOOL. This was the first public building for education, and it is currently our city hall. (Courtesy of Boulder Dam Museum.)

UNIDENTIFIED PEOPLE AT THE PLAYGROUND NEXT TO THE SCHOOL AND CLOSE TO ST. CHRISTOPHER'S EPISCOPAL CHURCH. (Courtesy of Boulder Dam Museum.)

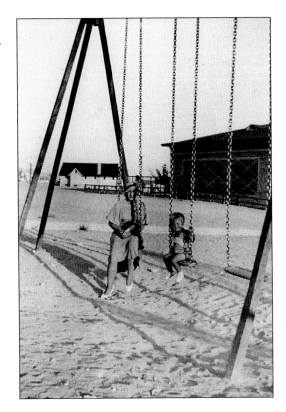

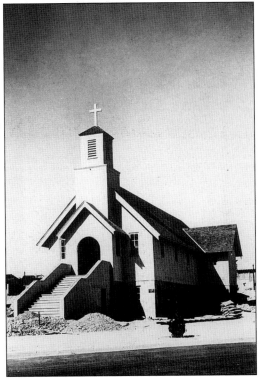

SAINT CHRISTOPHER'S EPISCOPAL CHURCH NEARING COMPLETION. (Photo by Ben D. Glaha, Courtesy of Bureau of Reclamation.)

PAT CLINE COMPANY AWARDED THE CONTRACT FOR BUILDING THE ROAD BETWEEN LAS VEGAS AND BOULDER CITY. The distance of this road was a little more than 20 miles, *c.* mid-1931. (Photo by W.A. Davis, Courtesy of Bureau of Reclamation.)

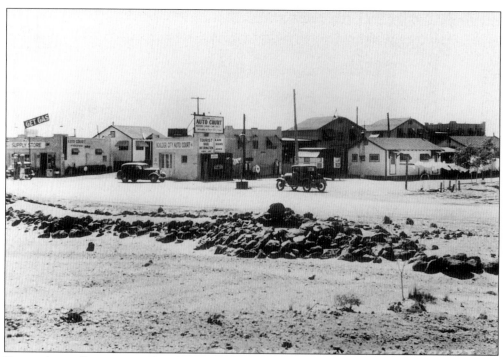

EARLY AUTO COURT AND GAS STATION. (Courtesy of Boulder Dam Museum.)

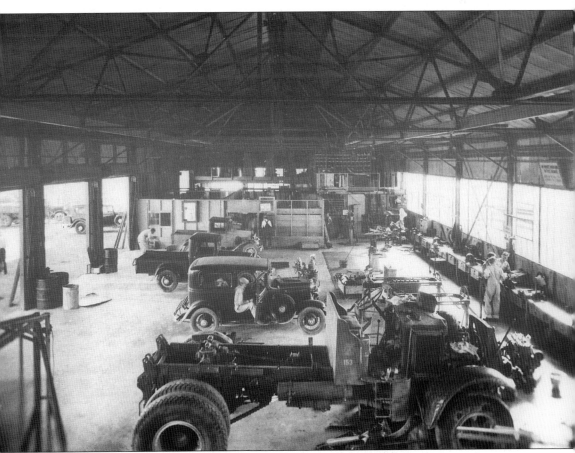

INTERIOR VIEW OF SIX COMPANIES INC. GARAGE AND AUTOMOBILE REPAIR SHOP IN BOULDER CITY. Complete facilities were installed for overhauling all classes of automobiles on August 15, 1932. (Photo by W.A. Davis, Courtesy of Bureau of Reclamation.)

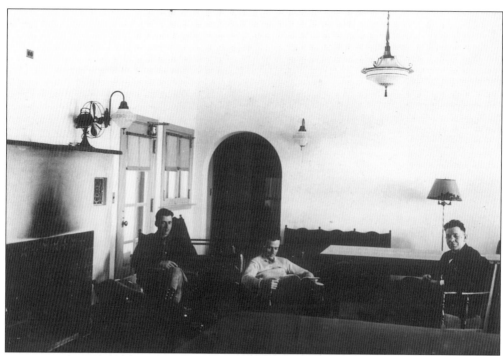

An Interior View of the Guest Lodge, February 28, 1932. (Photo by Ben D. Glaha, Courtesy of Bureau of Reclamation.)

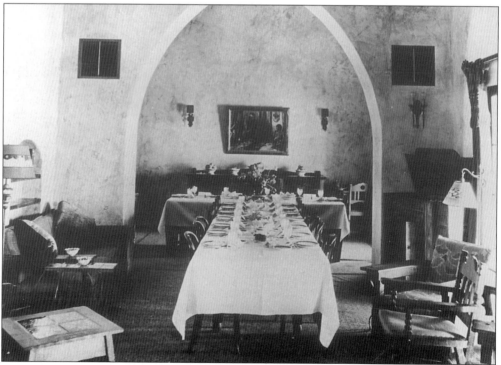

Interior View of the Guest Lodge for Visiting Dignitaries. (Courtesy of Boulder Dam Museum.)

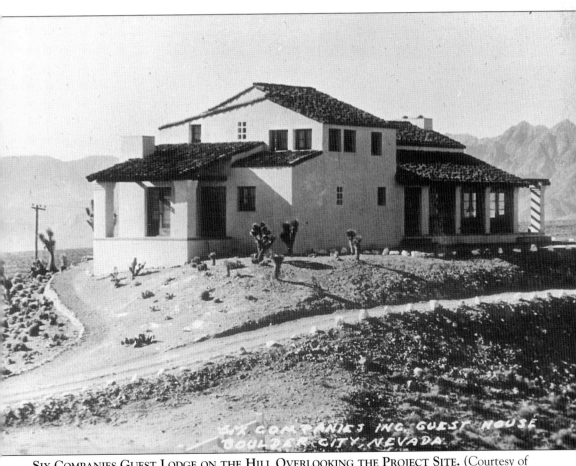

SIX COMPANIES GUEST LODGE ON THE HILL OVERLOOKING THE PROJECT SITE. (Courtesy of Boulder Dam Museum.)

DANCE
TOMORROW
EVENING

Friday, January 15, 1932

At the First Annual Ball, to be Given by the
Boulder City Post, No. 31

At The Six Company Mess Hall

Dance Starts at 9 P. M. Ends at 1 A. M.

Venetian Ballroom's Eight-Piece Orchestra

ADMISSION $1.00 LADIES FREE

NEWSPAPER AD ANNOUNCING THE FIRST ANNUAL BALL SPONSORED BY THE BOULDER
CITY AMERICAN LEGION POST 31. (Courtesy of Boulder Dam Museum.)

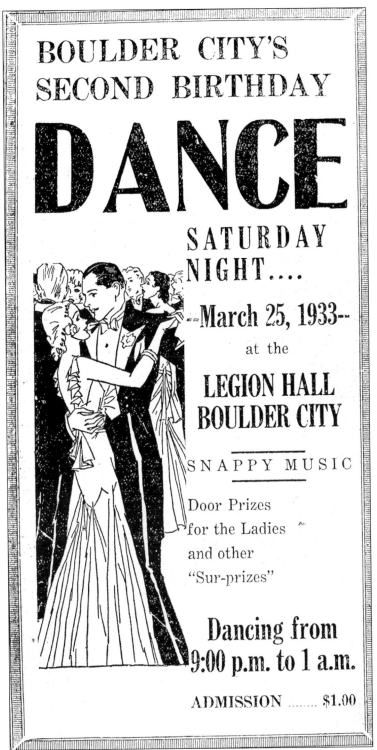

BOULDER CITY'S SECOND BIRTHDAY DANCE, MARCH 1933. (Courtesy of Boulder Dam Museum.)

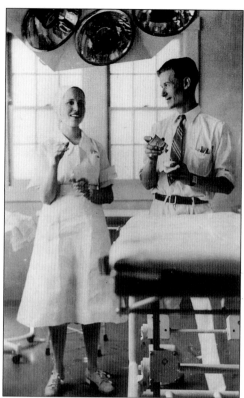

UNIDENTIFIED DOCTOR AND NURSE IN THE OPERATING ROOM OF THE SIX COMPANIES HOSPITAL. The only people who were entitled to medical care were the primary employees. Their dependents were not able to seek care at the hospital, which is now Wellspring Retreat House. (Courtesy of Boulder Dam Museum.)

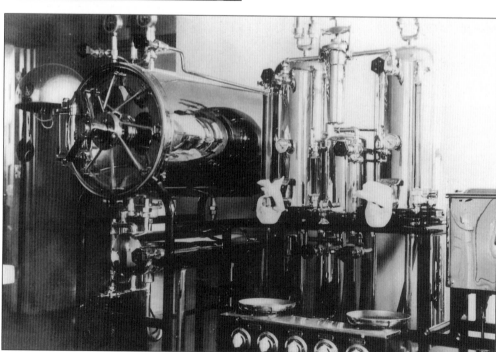

MODERN UP-TO-DATE EQUIPMENT AT THE SIX COMPANIES HOSPITAL. (Courtesy of Boulder Dam Museum.)

BILLY BUCK IN FAMILY HOUSING WARMING UP BY THE HEATER.
(Courtesy of Boulder Dam Museum.)

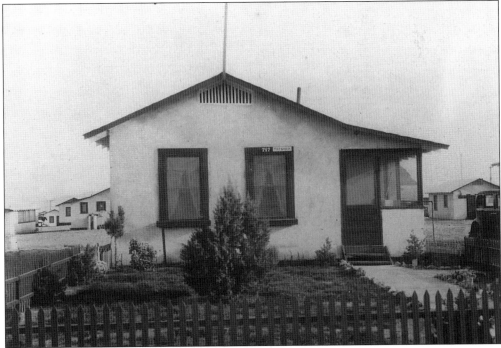

ONE OF THE SIX COMPANIES' MANY RESIDENCES BUILT FOR THE EMPLOYEES, MAY 7, 1932.
(Photo by G.A. Beyer, Courtesy of Bureau of Reclamation.)

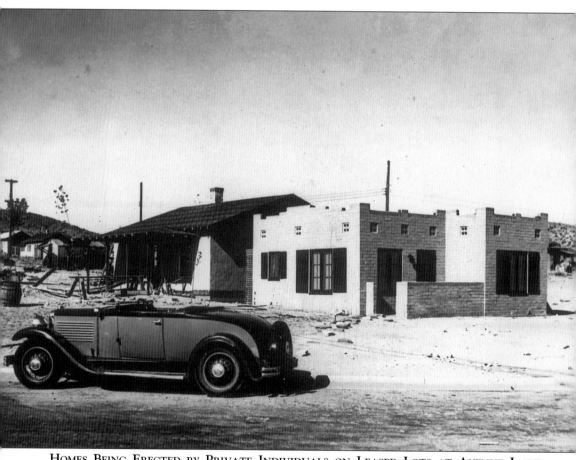

HOMES BEING ERECTED BY PRIVATE INDIVIDUALS ON LEASED LOTS AT AVENUE I AND
WYOMING STREET, AUGUST 20, 1932. (Photo by Ben D. Glaha, Courtesy of Bureau of
Reclamation.)

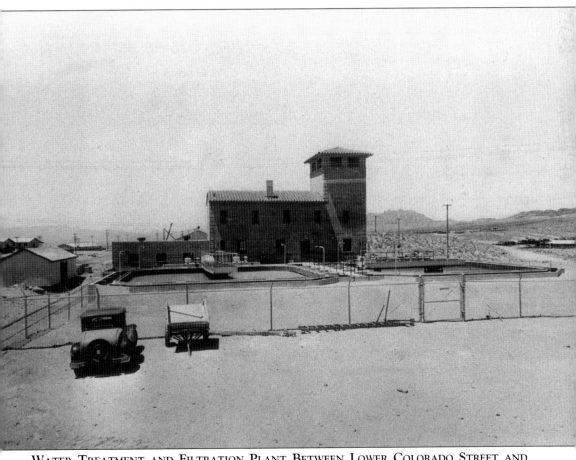

WATER TREATMENT AND FILTRATION PLANT BETWEEN LOWER COLORADO STREET AND RAILROAD AVENUE. This complete water system cost the government $500,000, *c.* 1932–33. (Photo by W.A. Davis, Courtesy of Bureau of Reclamation.)

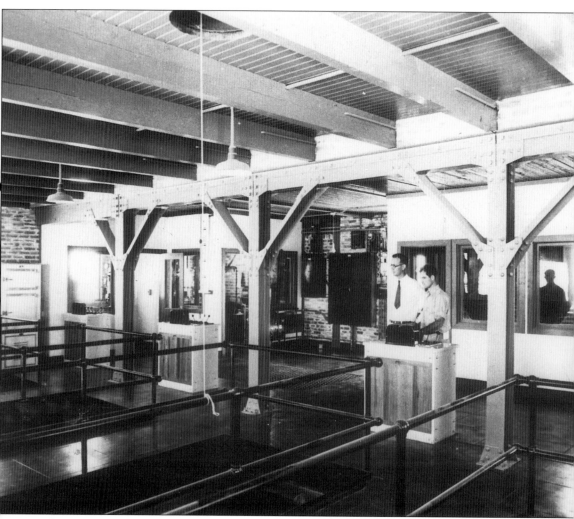

INTERIOR OF WATER TREATMENT AND FILTRATION PLANT IN BOULDER CITY SHOWING CONTROLS TO THE FILTER BEDS, C. 1931–33. (Photo by W.A. Davis, Courtesy of Bureau of Reclamation.)

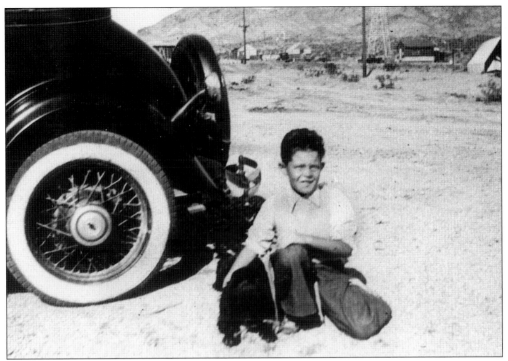

EDGAR BLAIR WITH DOG. (Courtesy of Boulder Dam Museum.)

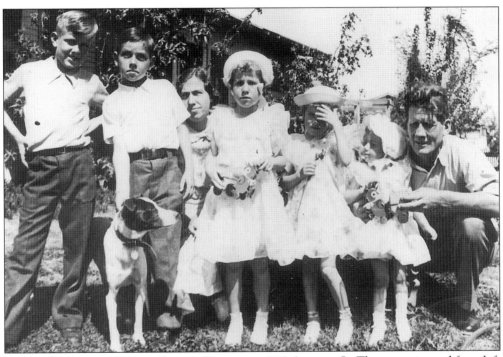

EASTER SUNDAY WITH THE GODBEY FAMILY AT 609 AVENUE L. They are, pictured from left to right: Tommy, Jimmy, Mother Erma Godbey, Laura, Ila, Alice, Father Tom Godbey, and their dog, Boulder, c. 1935. (Courtesy of the Godbey family.)

TYPICAL NEWSPAPER CLOTHING AD.
(Courtesy of Boulder Dam Museum.)

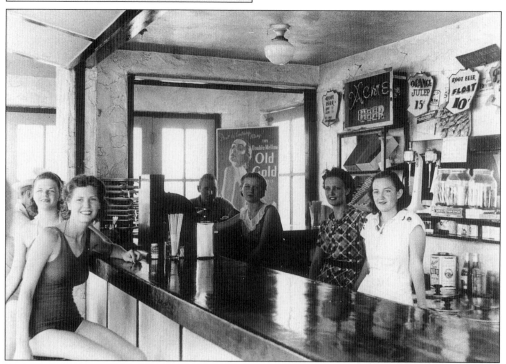

THE SODA FOUNTAIN, A POPULAR SPOT. (Courtesy of Boulder Dam Museum.)

CORNER OF WYOMING STREET AND AVENUE C, ONCE THE OLD LAUNDRY, APRIL 25, 2000. In the back section of this building is the large water tank used for cleaning purposes. This water tank was filled by a tanker truck, and later put on the water system. (Courtesy of MRPC.)

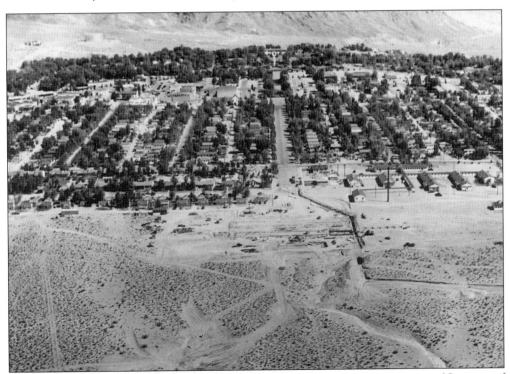

AERIAL PHOTOGRAPH OF BOULDER CITY SHOWING THE PLANNED COMMUNITY. (Courtesy of American Legion Post 31.)

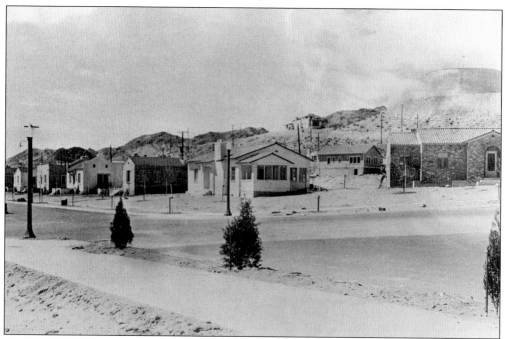

HISTORIC BOULDER CITY HOMES. The street to the right is Nevada Highway, and on the left is Colorado Street. Note the first water tank in the upper right of the picture, *c.* 1932. (Courtesy of American Legion Post 31.)

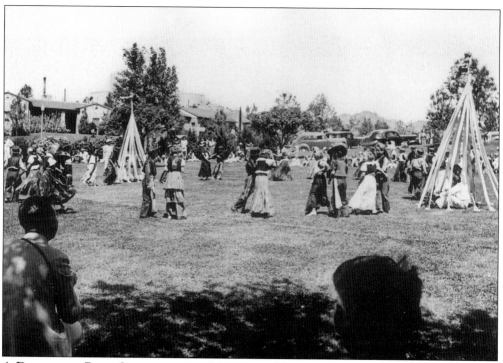

A DAY IN THE PARK COMPLETE WITH MAYPOLES. (Courtesy of the Godbey family.)

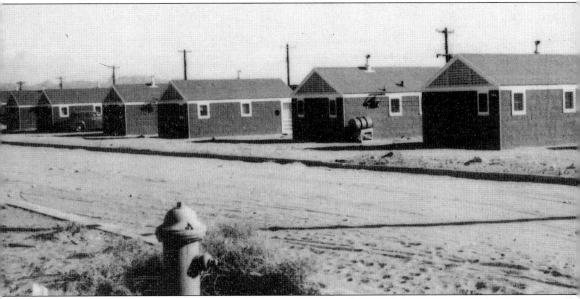

AVENUE M. These demountables on Avenue M were built during the summer of 1942. They were brought into Boulder City by the Bureau of Reclamation. (Courtesy of American Legion Post 31.)

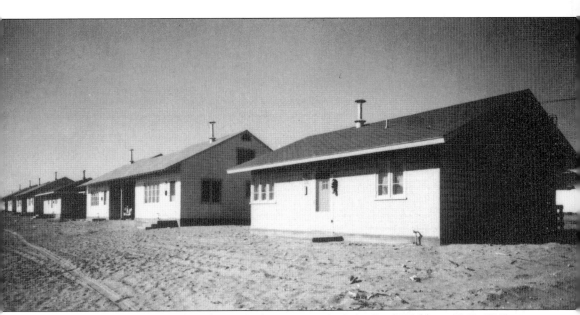

AVENUE B. These Bureau of Reclamation homes were built by Paul Webb in 1941–1942 on the block bound by Fifth Street, New Mexico Street, Avenue B, and California Avenue. (Courtesy of American Legion Post 31.)

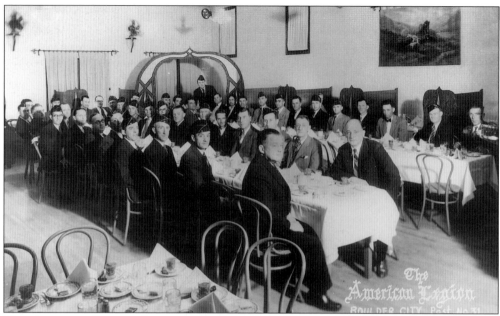

THE AMERICAN LEGION, BOULDER CITY POST 31, HOSTING A FORMAL DINNER IN THEIR HALL. The Legion was designated Post 31 because it was the year the Black Canyon Project actually began. It is the oldest social organization in Boulder City. (Courtesy of American Legion Post 31.)

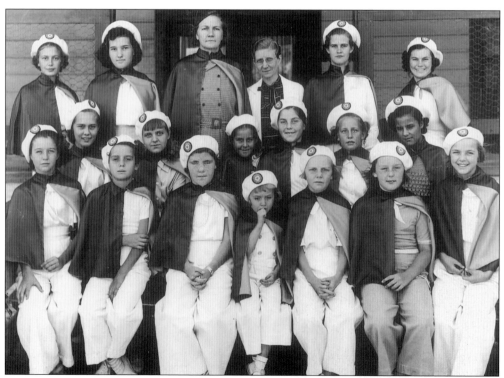

AMERICAN LEGION AUXILIARY JUNIORS. (Courtesy of American Legion Post 31.)

PRESIDENT FRANKLIN D. ROOSEVELT GIVING A BRIEF SPEECH AT THE DEDICATION OF THE DAM IN SEPTEMBER 1935. (Courtesy of American Legion Post 31.)

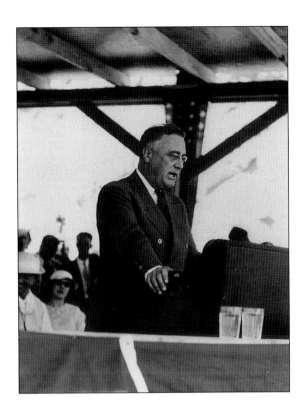

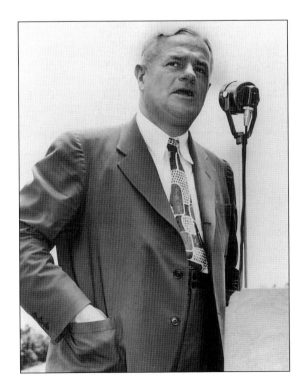

UNIDENTIFIED WASHINGTON D.C. DIGNITARY. (Courtesy of American Legion Post 31.)

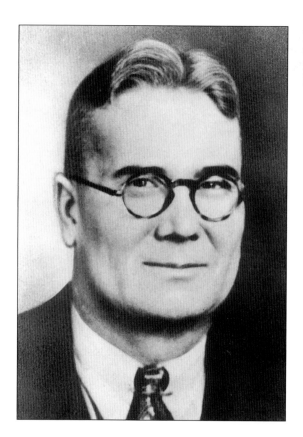

R.F. Skinner, the First Commander of American Legion Post 31. (Courtesy of American Legion Post 31.)

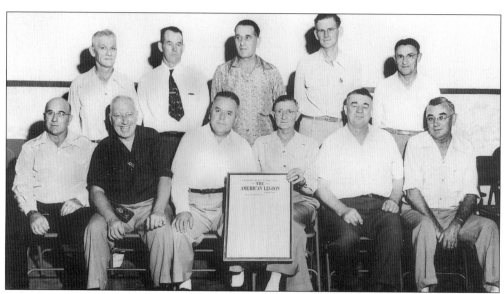

Charter Members of American Legion Post 31. They are, pictured from left to right: (front row) Cortez Cooper, Mort Wagner, Frank Wheelwright, Bob Mather, Wesley Nicholsen, Ben Vaughn; (back row) "Dusty" O.E. Rhoades, Frank Holtry, Mike Laux, Leo Courtney, and Leo Dunbar Sr. (Courtesy of American Legion Post 31.)

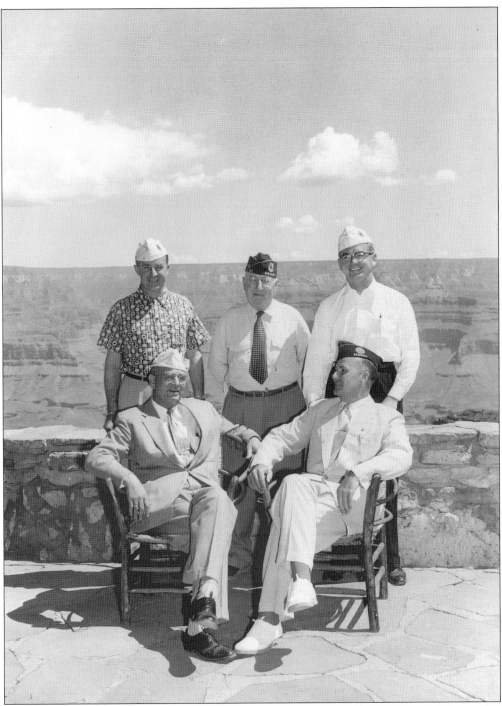

AMERICAN LEGION DELEGATES AT THE THE GRAND CANYON. They are, from left to right: (front row) unidentified members representing New Mexico and Georgia; (back row) California representative, Mort W. Wagner, Commander of Boulder City Post 31, and unidentified member. The white American Legion hats signify the national level. (Courtesy of American Legion Post 31.)

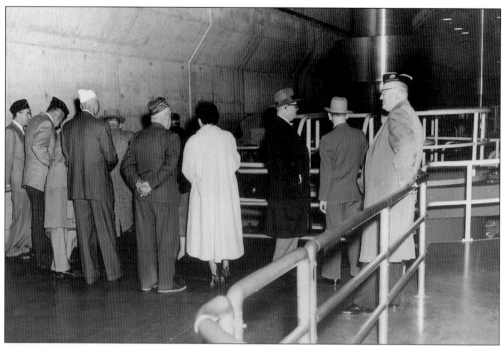

NATIONAL COMMANDER AND LEGIONNAIRES VIEWING WORKINGS AT THE DAM, DECEMBER 30, 1953. (Courtesy of American Legion Post 31.)

AMERICAN LEGION NATIONAL COMMANDER VISITS HOOVER DAM, DECEMBER 30, 1953. (Courtesy of American Legion Post 31.)

AMERICAN LEGION POST 31 MEMBERS BARNEY GINO AND MORT W. WAGNER. Mort was the alternate national executive committeeman and the commander of Post 31. (Photo by Western Studio, Las Vegas, Nevada, Courtesy of American Legion Post 31.)

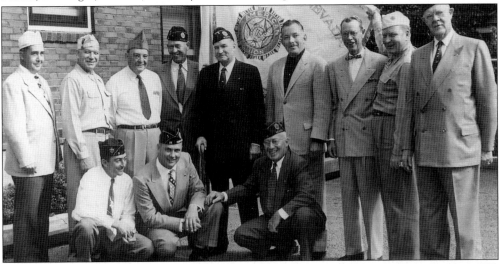

PRESENTATION OF NEVADA AMERICAN LEGION FLAG TO U.S. SENATOR GEORGE W. MALONE UPON MEETING THE DEPARTMENT EXECUTIVE COMMITTEE IN RENO, NEVADA, SUNDAY, SEPTEMBER 27. Standing, from left to right, they are: Department Vice Commander Calvin J. Dodson (Sparks), Department Historian Lester Page (Yerington), Department Judge Advocate Thomas J.D. Salter (Reno), Department Commander-Elect Ed M. White Sr., Senator Malone, Junior Past Department Commander Madison B. Graves (Las Vegas), First District Commander G.A. Rogers (Reno), Department Adjutant Victor F. Whittlesea, and National Committeeman Thomas W. Miller. Kneeling, from left to right, are: Fourth District Commander Remo Matteucci (Fallon), Department Membership Chairman L.A. Robertson (Hawthorne), and Alternate National Executive Committeeman Mort W. Wagner (Boulder City). White hats signify American Legion National Level positions. (Photo by Jimmy Nickell, Reno, Nevada, Courtesy of American Legion Post 31.)

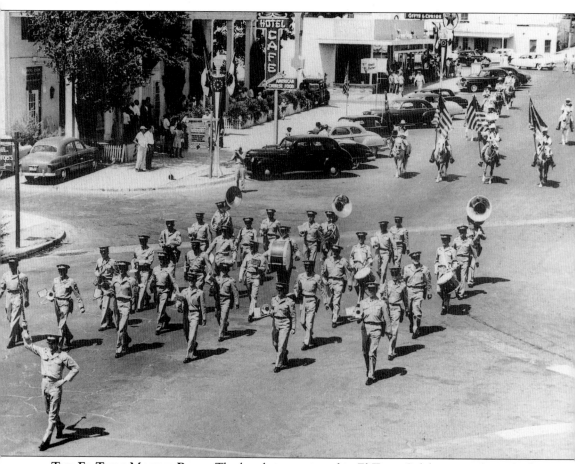

THE EL TORO MARINE BAND. The band was stationed in El Toro, California, and marched in the Damboree Parade two years in a row, 1949–50. (Courtesy of American Legion Post 31.)

Damboree Parade, the Sons of the American Legion Marching Down Arizona Street. Note the Historic Boulder Dam Hotel. (Photo by William Belknap Jr., Courtesy of American Legion Post 31.)

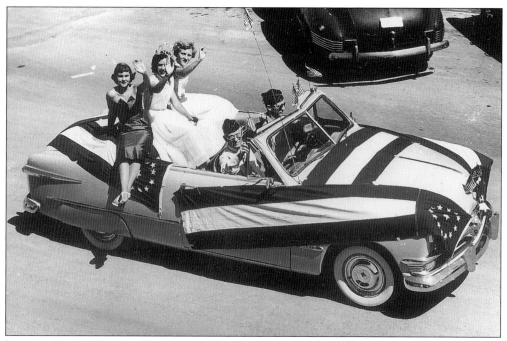

LEFT TO RIGHT: GLORIA BAUCKMAN, FLORENCE TOBLER, THE REIGNING MISS DAMBOREE, AND MARLENE MOORE DRIVEN IN THE DAMBOREE PARADE BY TWO UNIDENTIFIED AMERICAN LEGION MEMBERS. The Damboree Parade is still a tradition that is held yearly around the 4th of July. This festive event started in 1950 and was the brainchild of Mort W. Wagner, American Legion Post 31 Commander. (Courtesy of American Legion Post 31.)

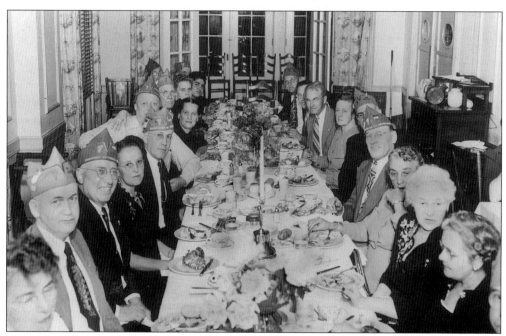

AMERICAN LEGION POST 31 DINNER HELD AT THE BOULDER DAM HOTEL. (Courtesy of American Legion Post 31.)

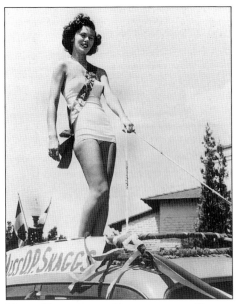

MISS DAMBOREE CONTESTANT SUSAN SHEPPARD GILMORE, SPONSORED BY O.P. SKAGGS. (Courtesy of American Legion Post 31.)

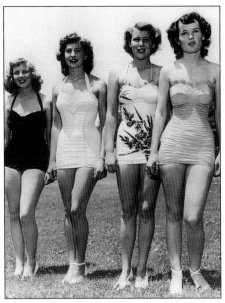

MISS DAMBOREE CONTESTANTS. Left to right, they are: Rae Kennedy, Carolyn Cowan, Susan Schwartz Broadbent, and MaryLou Moses McCullum. (Photo by Lawrence Battey, Belknap Photographic Services, Boulder City, Nevada. Courtesy of American Legion Post 31.)

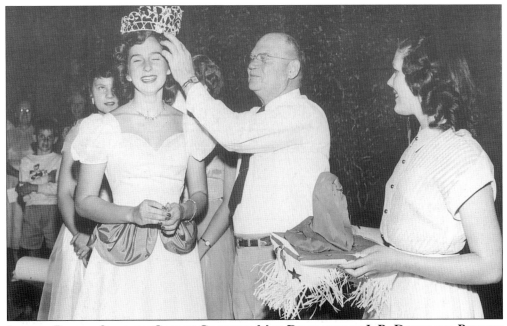

LEFT TO RIGHT: CAROLYN COWAN CROWNED MISS DAMBOREE BY L.R. DOUGLASS, BUREAU OF RECLAMATION OFFICIAL, AS FLORENCE TOBLER, THE PREVIOUS MISS DAMBOREE, GIVES UP HER CROWN, C. 1950. (Photo by Cliff Segerblom, Courtesy of American Legion Post 31.)

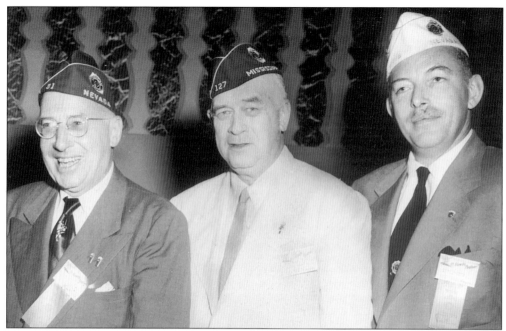

LEFT TO RIGHT: MORT WAGNER, AMERICAN LEGION NATIONAL COMMANDER AND A MEMBER OF POST 31; UNIDENTIFIED MISSISSIPPI POST 127 MEMBER; AND UNIDENTIFIED LAS VEGAS, NEVADA, POST 8 MEMBER. (Photo by Ray Vincent, Las Vegas, Nevada. Courtesy of American Legion Post 31.)

AMERICAN LEGION POST 31 MEMBERS. They are, pictured from left to right: Vic Whittlesea, Tom Godbey, Ted Garrett, Mort Wagner, and "Hope" Moller. (Courtesy of American Legion Post 31.)

A SAILOR TAKES A BRIDE. Chris and Bill married March 12, 1953, at Grace Community Church. (Courtesy of American Legion Post 31.)

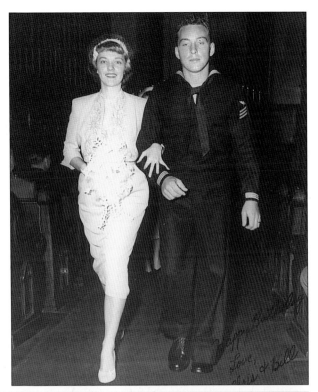

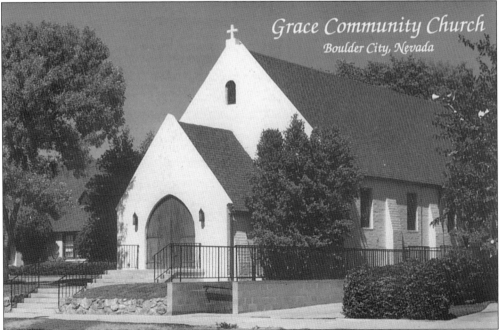

HISTORIC GRACE COMMUNITY CHURCH. This congregation was founded in 1933 to serve the religious needs of the Hoover Dam workers. It is dedicated to being multi-denominational and ecumenical. Pastors have represented Presbyterian, Congregational, and Methodist Churches since its origination. (Courtesy of Grace Community Church, photo by Gretchen L. Wilson.)

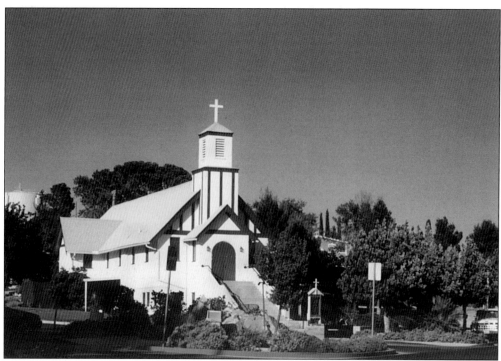

SAINT CHRISTOPHER'S EPISCOPAL CHURCH, ONE OF THE FIRST CHURCHES IN BOULDER CITY, ON APRIL 25, 2000. (Courtesy of MRPC.)

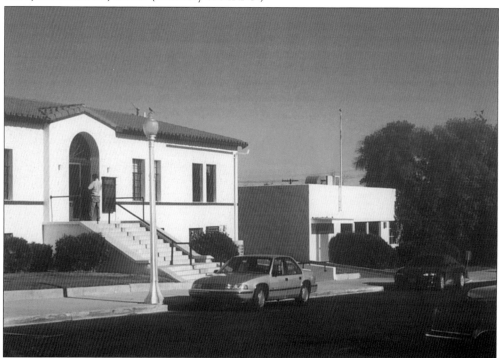

SIDE VIEW OF THE BOULDER CITY POLICE DEPARTMENT FACING CALIFORNIA STREET, APRIL 25, 2000. The square building on the right is the old post office. (Courtesy of MRPC.)

FIRST BUILDING OF BOULDER CITY COMPLEX COMPLETED. The left portion of this building is the Boulder City Senior Center, and the right portion is the police department, the first municipal building from which Sims Ely worked. Photo taken April 25, 2000. (Courtesy of MRPC.)

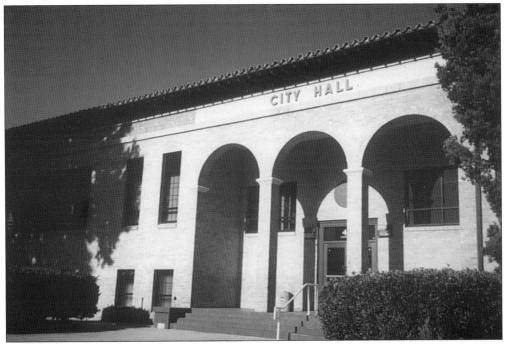

VIEW OF CITY HALL'S FINE ARCHITECTURAL DETAILS, APRIL 25, 2000. (Courtesy of MRPC.)

SIDE VIEW OF CITY HALL FACING ARIZONA STREET, APRIL 25, 2000. Note the detailed brick work. (Courtesy of MRPC.)

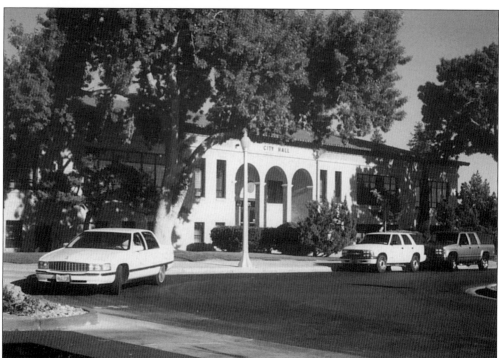

VIEW FROM CALIFORNIA STREET AT CITY HALL IN BOULDER CITY, APRIL 25, 2000. This building was originally the first grade school. (Courtesy of MRPC.)

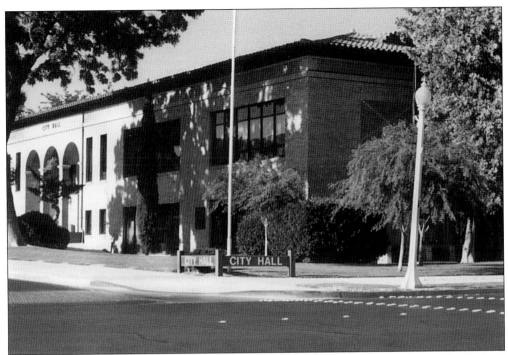

LOOKING FROM ARIZONA STREET TOWARDS CITY HALL IN BOULDER CITY. (Courtesy of MRPC.)

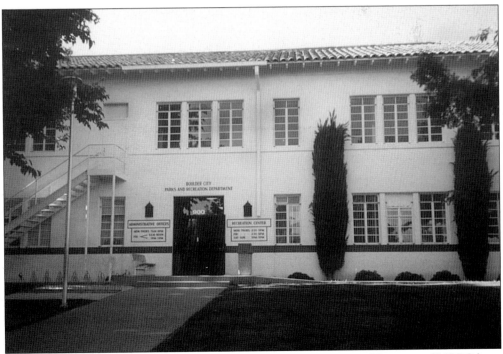

PARK AND RECREATION BUILDING WAS THE FIRST HIGH SCHOOL. (Courtesy of MRPC.)

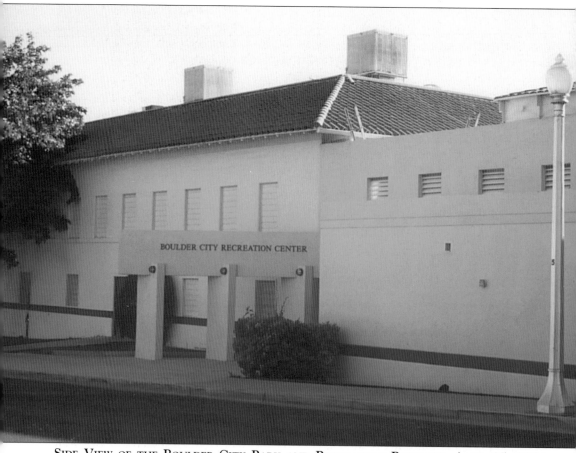

BOULDER CITY RECREATION CENTER

SIDE VIEW OF THE BOULDER CITY PARK AND RECREATION BUILDING, APRIL 25, 2000.
(Courtesy of MRPC.)

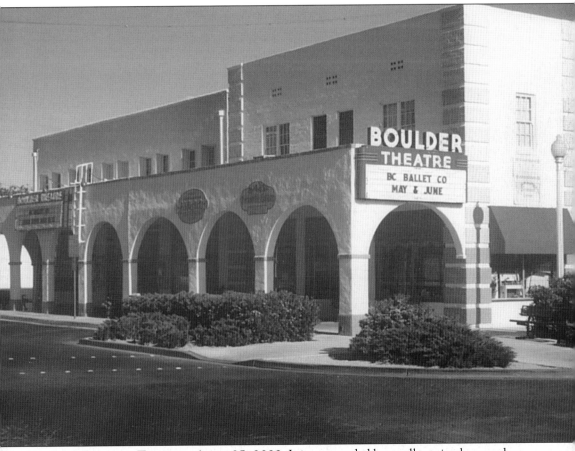

HISTORIC BOULDER THEATRE, APRIL 25, 2000. It is surrounded by small tourist shops and an attorney's office. This theatre had refrigerated air and operated 24 hours a day, which made it very popular. The corner site first served as a hardware store. (Courtesy of MRPC.)

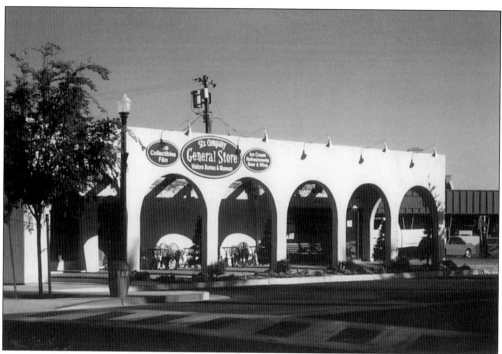

Six Companies General Store. This photo, taken April 25, 2000, faces Nevada Highway. The store is now a local tourist shop—the arches are new. (Courtesy of MRPC.)

Vanna's Gourmet Beverage and Cafe on Arizona Street. The newly restored arches echo the master plan. (Courtesy of MRPC.)

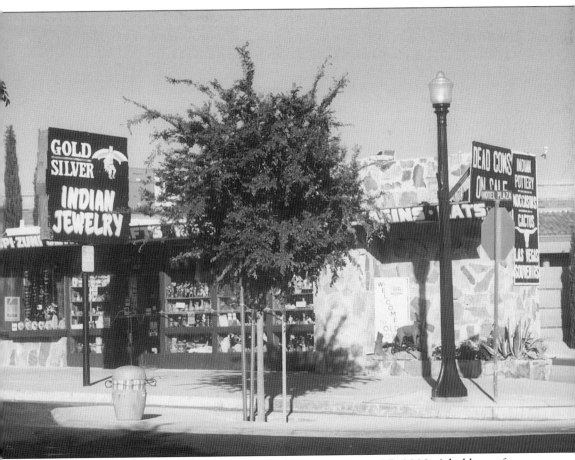

MEXICAN WESTERN CENTER FACING NEVADA HIGHWAY, APRIL 25, 2000. A hold-over from the 1940s, it was initially used as a photographer's studio. (Courtesy of MRPC.)

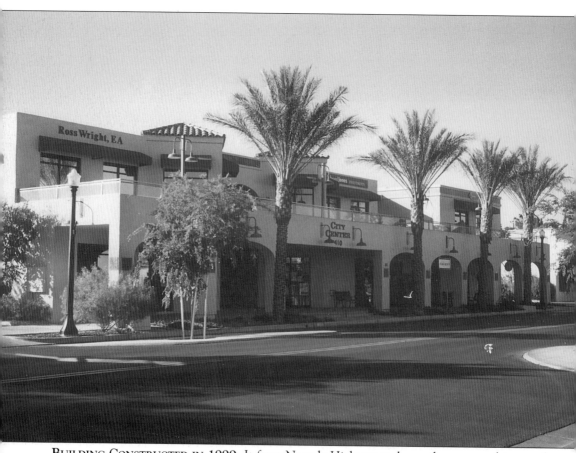

BUILDING CONSTRUCTED IN 1999. It faces Nevada Highway and uses the same architectural facade as other older buildings on the street. (Courtesy of MRPC.)

LOOKING SOUTHWEST DOWN NEVADA HIGHWAY AT NEWLY PLANTED TREES. Note the original arches. (Courtesy of MRPC.)

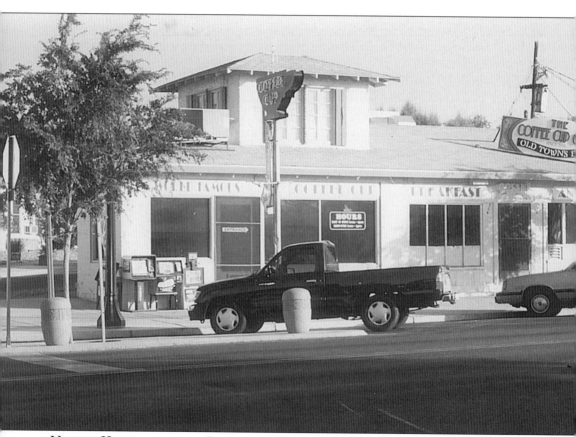

NEVADA HIGHWAY, AT THE CORNER OF WYOMING STREET, APRIL 25, 2000. This structure housed one of the first privately owned restaurants in town. It continues to serve the community, and is a favorite breakfast stop for local business people. (Courtesy of MRPC.)

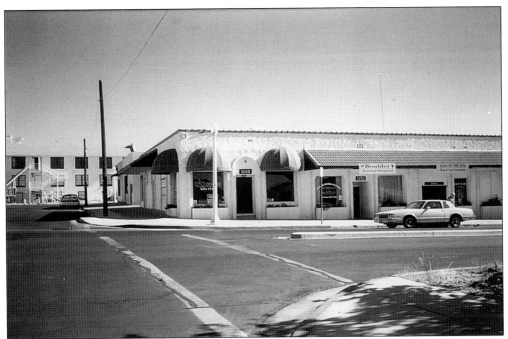

TYPICAL STOREFRONTS FOUND ON ANY BLOCK IN THE DOWNTOWN HISTORIC DISTRICT, APRIL 25, 2000. (Courtesy of MRPC.)

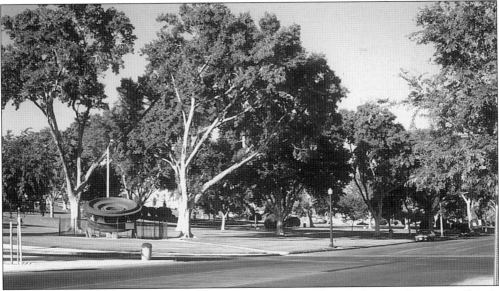

BOULDER CITY'S MOTTO IS "CLEAN, GREEN BOULDER CITY." ONE OF BOULDER CITY'S FINEST PARKS, WILBUR SQUARE, ALSO KNOWN AS GOVERNMENT SQUARE. Directly to the left in the picture is an original turbine from the dam. Every year, during the first weekend of October, over three hundred artists and craftsmen come from all over the United States to sell their wares at "Art in the Park." The Boulder City Hospital Auxiliary sponsors this popular event. All funds raised from the juried Art Show, vendor booth rentals, and food booths go to the Boulder City Hospital to purchase state-of-the-art medical equipment (Courtesy of MRPC.)

ONE OF THE FIRST HOMES WITH GRASS AND ROCKS IN THE FRONT YARD, APRIL 25, 2000. (Courtesy of MRPC.)

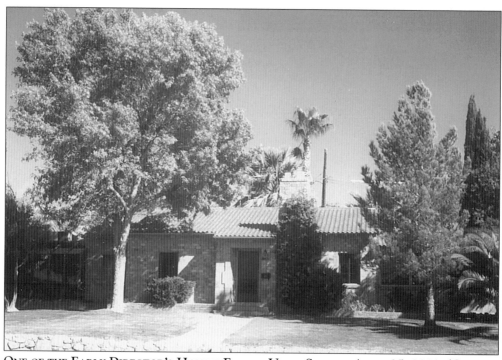

ONE OF THE EARLY DIRECTOR'S HOUSES FACING UTAH STREET, APRIL 25, 2000. (Courtesy of MRPC.)

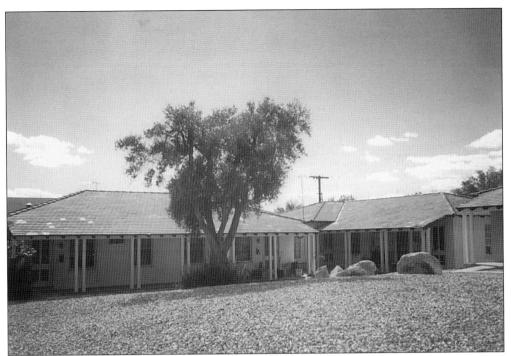

ORIGINAL DUPLEXES IMMEDIATELY ADJACENT TO THE LOS ANGELES WATER AND POWER BUILDING, APRIL 25, 2000. These were constructed for the first power operators' homes. (Courtesy of MRPC.)

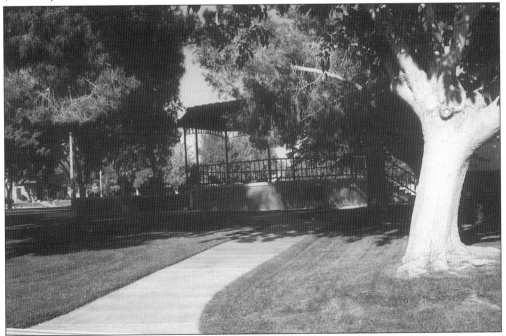

GAZEBO AT BICENTENNIAL PARK, APRIL 25, 2000. Various performers often use this for an afternoon or evening of music or dance performances. The park and the gazebo were Bicentennial projects for Boulder City. (Courtesy of MRPC.)

One of the original Bureau of Reclamation Homes Facing Utah Street, April 25, 2000. (Courtesy of MRPC.)

Alley Accessible Historic Homes with Uninterrupted Front Streetscape, April 25, 2000. (Courtesy of MRPC.)

BEAUTIFUL GREEN BACKYARD OF ONE OF THE HISTORIC HOMES, APRIL 25, 2000. (Courtesy
of MRPC.)

SOME HOMES IN BOULDER CITY WITH ROCK YARDS TO KEEP WATER COSTS DOWN, APRIL 25, 2000. (Courtesy of MRPC.)

DIFFERENCES IN YARDS, APRIL 25, 2000. Some of them are grassy and others are rock, often with geological specimens from the desert. (Courtesy of MRPC.)

REMODELED HISTORIC HOME BORDERING AVENUE K AND WYOMING STREET, APRIL 25, 2000. (Courtesy of MRPC.)

HOUSE BUILT IN 1931 FOR ONE OF THE PROJECT DIRECTORS, APRIL 25, 2000. (Courtesy of MRPC.)

NEVADA HIGHWAY HOME, ONE OF SIX ORIGINAL DESIGNS, APRIL 25, 2000. Note the intricate brickwork on the arch. (Courtesy of MRPC.)

HISTORIC BUREAU OF RECLAMATION HOME LOCATED ON NEVADA HIGHWAY AND COLORADO STREET, APRIL 25, 2000. (Courtesy of MRPC.)

ASSIGNED HOUSE FOR ONE OF THE TOP MANAGEMENT PEOPLE. This house was built by the Bureau of Reclamation in 1931 and was assigned to Morgan Sweeney and his family. Note the intricate brickwork and the red tile roof. (Courtesy of MRPC.)

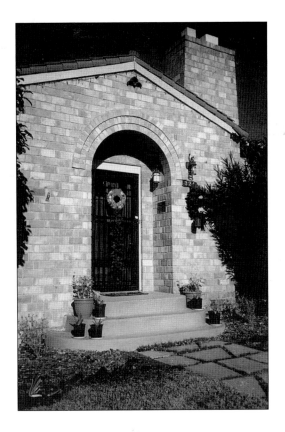

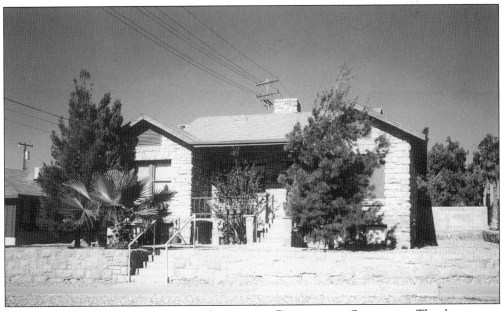

NATIVE STONE OR ROCK HOUSE PRIVATELY BUILT AND OCCUPIED. The house was constructed from unusual materials found in the area. (Courtesy of MRPC.)

ORIGINALLY A FRAMED HOUSE OFF CALIFORNIA AVENUE, APRIL 25, 2000. This residence has been remodeled, and the exterior is now stucco. (Courtesy of MRPC.)

ANOTHER FRAMED COTTAGE WITH A COMPLETELY NEW EXTERIOR, APRIL 25, 2000. (Courtesy of MRPC.)

Nevada Highway Facade of the Administration Wing of the Los Angeles Water and Power Building, April 25, 2000. Note the evergreen trees and some of the historic plantings. (Courtesy of MRPC.)

One of the Many Remodeled Company Homes From the Avenues, April 25, 2000. (Courtesy of MRPC.)

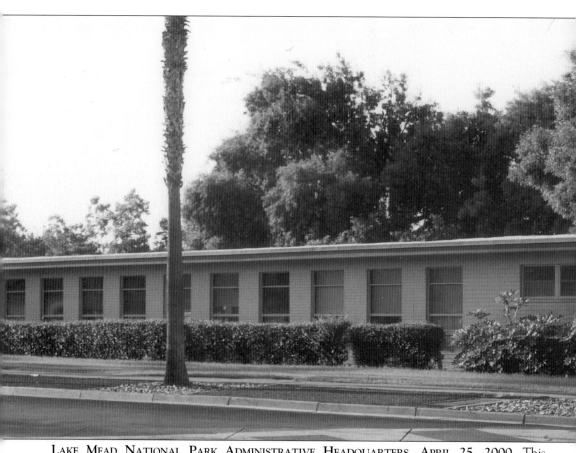

LAKE MEAD NATIONAL PARK ADMINISTRATIVE HEADQUARTERS, APRIL 25, 2000. This

structure represents the strong international influence used in public buildings. (Courtesy MRPC.)

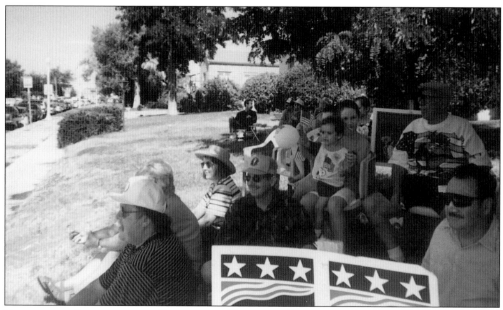

PROPERTIES CLOSE TO THE PARK WITH RINGSIDE SEATS FOR PARADES. Boulder City has traditionally hosted no less than four major parades a year, and people gather simply to enjoy these old-fashioned parades. The Spring Jamboree is held the first weekend in May—complete with a lovely dance recital, a crafts fair, and a variety of other community activities. The Fourth of July parade is the state's largest. The weekend festivities include a band concert in the park and games for all ages. Boulder City High School class reunions are traditionally held on the Fourth of July weekend. Many of the local churches meet together for an ecumenical service in Wilbur Park to celebrate our nation's birthday. The celebration ends with a gigantic fireworks show. In October, Boulder City High School hosts their Homecoming Parade with the full participation of each class. The Christmas Parade is held yearly on the first weekend of December. Mr. and Mrs. Santa Claus arrive to light the community Christmas tree and then host a homemade cookie and hot chocolate party in the park. (Courtesy of MRPC, July 4, 1998.)

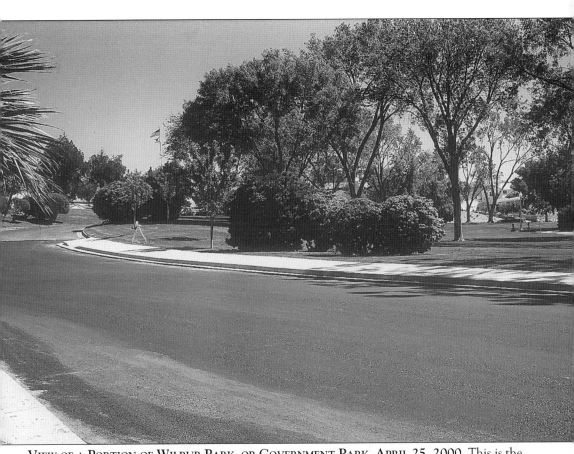

VIEW OF A PORTION OF WILBUR PARK, OR GOVERNMENT PARK, APRIL 25, 2000. This is the location for most of the outdoor activities held in Boulder City. (Courtesy of MRPC.)

ESCALANTE PLAZA BISECTED BY ARIZONA STREET, APRIL 25, 2000. It is the final segment of community park that cascades down the hill from the Bureau of Reclamation Administrative offices. (Courtesy of MRPC.)

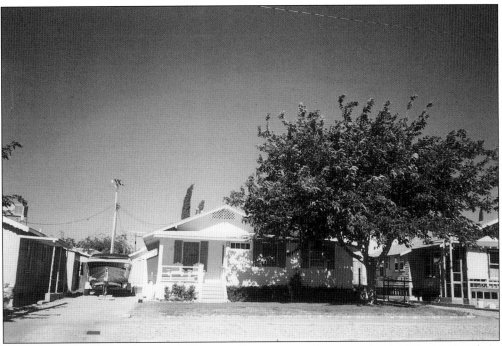

CHARMING ORIGINAL COTTAGE FACING CALIFORNIA AVENUE, APRIL 25, 2000. These frame homes have, for the most part, all been remodeled. This one retains its original street facade, and the house looks today as it did 60 years ago. (Courtesy of MRPC.)

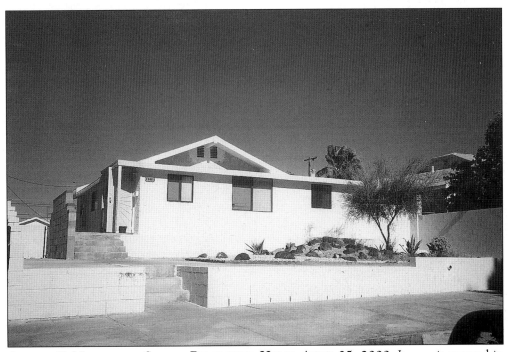

AVENUE D MODEL OF A SIMPLE, REMODELED HOME, APRIL 25, 2000. It now is encased in stucco, and none of the original details remain. (Courtesy of MRPC.)

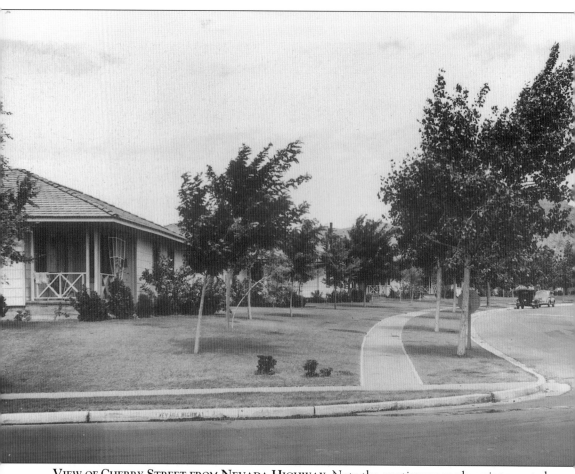

VIEW OF CHERRY STREET FROM NEVADA HIGHWAY. Note the contiguous yards, uninterrupted space, uniform setbacks, and detailed landscaping. There are no intrusions in this streetscape as originally planned. (Courtesy of Bureau of Reclamation.)

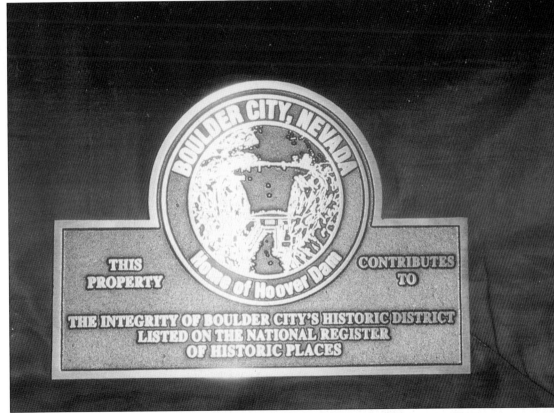

NATIONAL REGISTER OF HISTORIC PLACES RECOGNIZED BOULDER CITY AS A HISTORIC DISTRICT IN THE EARLY 1980S. Those structures that continue to contribute to the National Register Listing are being marked with the above plaque. (Courtesy of Rose Ann Miele Rabiola.)

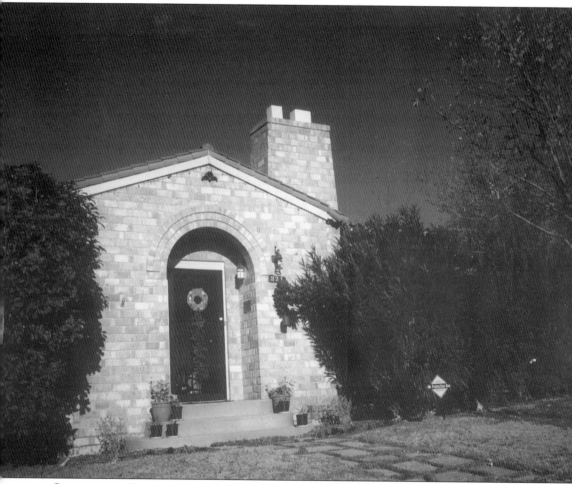

ONE OF THE EARLIEST RESIDENCES. This historic home is a contributing structure to the Boulder City Historic District. It contains all its original features, both inside and out, and serves as a reminder of the past and the lasting imprint of our nation's first planned community. (Courtesy of MRPC.)